KAHLO	MEMLING	POLLOCK	
KANDINSKY	MICHELANGELO	PONTORMO	SOUTINE
KAUFFMANN	MILLET	POUSSIN	SPENCER
KIRCHNER	MIRÓ	RAPHAEL	STUBBS
KLEE	MODERSOHN-BECKER	RAUSCHENBERG	TIEPOLO
KLIMT	MODIGLIANI	REDON	TINTORETTO
KOKOSCHKA	MONDRIAN	REGO	TITIAN
KRASNER	MONET	REMBRANDT	TOULOUSE-LAUTREC
LA TOUR	MOORE	RENOIR	TURNER
LAWRENCE	MOREAU	REYNOLDS	UCCELLO
LÉGER	MORISOT	RIVERA	UTRILLO
LEONARDO	MORRIS	ROBBIA	VAN DER WEYDEN
LICHTENSTEIN	MOTHERWELL	ROCKWELL	VAN DYCK
LIMBOURG Brothers	MUNCH	RODIN	VAN EYCK
LIPPI	MURILLO	ROSSETTI	VAN GOGH
LORRAINE	NEWMAN	ROTHKO	VAN HONTHORST
LOTTO	NOLAN	ROUAULT	VAN RUISDAEL
LOWRY	NOLDE	ROUSSEAU	VELÁZQUEZ
MACKE	O'KEEFFE	RUBENS	VERMEER
MAGRITTE	OLDENBURG	RUBLEV	VERONESE
MALEVICH	OROZCO	RYDER	VUILLARD
MANET	PERUGINO	SARGENT	WARHOL
MANTEGNA	PICASSO	SASSETTA	WATTEAU
MARC	PIERO	SCHIELE	WEST
MARIN	PIPPIN	SEGAL	WHISTLER
MARTINI	PISANO	SEURAT	WOOD
MASACCIO	PISSARRO	SHAHN	WYETH
MATISSE		SISLEY	ZURBARÁN

ENCYCLOPEDIA *of* ARTISTS

6

ART MOVEMENTS, GLOSSARY, AND INDEX

Consulting Editor
Professor William Vaughan
BIRKBECK COLLEGE, UNIVERSITY OF LONDON

Contributors

Christopher Ackroyd	*Flavia Heseltine*	*Claire O'Mahony*	*Anthea Peppin*
Michael Bird	*Michael Howard*	*Mike O'Mahony*	*Ailsa Turner*
Maria Costantino	*Debbie Lewer*	*Chris Murray*	*Giles Waterfield*
Michael Ellis	*Rebecca Lyons*	*Alice Peebles*	*Iain Zaczek*

Planned and produced by
Andromeda Oxford Limited
11-13 The Vineyard
Abingdon
Oxon OX14 3PX
UK

www.andromeda.co.uk

Copyright © Andromeda Oxford Limited 2000

Printed in Hong Kong

Project Director *Graham Bateman*

Managing Editors *Jo Newson, Penelope Isaac*

Art Editor and Designer *Steve McCurdy*

Editorial Assistant *Marian Dreier*

Picture Manager *Claire Turner*

Picture Researcher *David Pratt*

Production *Clive Sparling*

Index *Indexing Specialists, Hove, East Sussex*

Published in the United States of America by
Oxford University Press, Inc.
198 Madison Avenue
New York, NY 10016

www.oup.com

Oxford is a registered trademark of Oxford University
Press

ISBN 0-19-521572-9

Library of Congress Cataloging-in-Publication Data

Encyclopedia of artists / edited by William H.T. Vaughan.
p.cm.
ISBN 0-19-521572-9
*1. Art--Encyclopedias. 2. Artists--Biography. I. Vaughan,
William H.T.*

N31 .E53 2000
709'.2'2--dc21
[B] 00-027167

Contents

Using this encyclopedia

THIS SIX-VOLUME ENCYCLOPEDIA provides a comprehensive, highly illustrated introduction to Western art from the Middle Ages to the present day.

The first five volumes contain biographies of more than 200 painters, sculptors, and printmakers. For ease of use, the entries are arranged alphabetically, and one double-page spread is devoted to each artist.

Within each double-page spread the information is divided into three sections. A data file summarizes key facts about the artist's life and work, names other artists whose work is comparable, and notes relevant glossary terms. The meanings of these are explained in the comprehensive glossary in Volume 6.

1100	1200	1300	1400

Romanesque

Italian Renaissance

European Gothic

International Gothic

Byzantine

1800	1850

Neoclassicism/Romanticism

Impressionism

Hudson River School

Pre-Raphaelites

Barbizon School

Symbolism and Art Nouveau

Avant-garde

Realism

The main text focuses on the artist's life and work in detail, while a feature box describes the artist's style, with particular reference to one or two of his or her key works, which are illustrated. Where appropriate, diagrams are used to describe artistic processes, or to show how artists achieved certain effects.

The final volume provides a further reference resource. It contains fully illustrated articles on the principal artistic styles and movements over the last 1,000 years, arranged in alphabetical order. It also includes a glossary, in which definitions of terms can be found; recommendations for further reading; and a master index that contains comprehensive listings and cross-references.

1500	1600	1700	1800

Baroque

Northern Renaissance

Neoclassicism/Romanticism

Mannerism

Rococo

Utrecht School

Realism

1900	1950

Bauhaus

Pop/Op Art

Primitivism

De Stijl

Abstract Art

Conceptual Art

Postimpressionism

Constructivism

Abstract Expressionism

Fauvism and Expressionism

Postmodernism

Die Brücke Harlem Renaissance

Minimalism

Ashcan School Cubism and Futurism

Der Blaue Reiter

Dada and Surrealism

ABSTRACT ART

The term "abstract art" is used generally to describe images that do not represent real objects. Abstraction has been a recurring concept in art throughout history, and can be seen in cave paintings and in decorative art. The term is more specifically used to refer to the work of some 20th-century European and American artists who reacted against the traditional idea that art should "imitate" nature. These artists wanted to explore and reveal different areas of experience, such as pure feelings and emotions, or the qualities and "harmonies" of color.

Abstract art is not a style, but an approach, so there can be as many different types of abstract art as there are artists. Some artists prefer their art to be described as nonrepresentational, while Piet Mondrian used the term neoplasticism, meaning a new kind of

Red Knot by **Wassily Kandinsky** *1936. Oil on canvas. 33 x 24 in (84 x 61 cm). Fondacion Maeght, Saint-Paul.*

reality, to define his approach. Others spoke of "pure," "concrete," or "constructed" art. Historians tend to describe such art as nonfigurative.

The first wholly nonrepresentational paintings were produced by the Russian artist Wassily Kandinsky in about 1913; by the end of World War I artists like Kandinsky, Mondrian, and Kasimir Malevich were creating paintings that did not rely on the appearance of objects, but on the laws of color and form. This allowed artists to adopt either a loose, free-form stylistic approach (like Kandinsky), or a rigid geometric approach (like Mondrian).

In France in the 1920s, artists such as Joan Miró, who were influenced by surrealism, created a form of abstract art

in which their paintings were supposed to be reflections of their unconscious minds. Meanwhile, others—Le Corbusier and Amedee Ozenfant among them—took a more rational, mathematical approach to produce their "purist" abstractions.

The works and ideas of these early pioneers encouraged later artists to explore different approaches to abstract art, and consequently new forms such as constructivism and concrete art were introduced. After World War II, many artists found the geometric approach too restricting and, in their search for an art form that expressed their own psychological and emotional experiences, turned to a looser, more gestural form of abstract art. In Europe, this kind of abstraction had several names, such as matter painting, lyrical abstraction, or tachisme, but in the United States it was known by its more familiar name of abstract expressionism.

In the 1960s abstract art perhaps achieved its greatest popularity in the kinetic art of Alexander Calder (who invented the mobile), and the optical or op art of Bridget Riley. In the 1970s abstract art was characterized by extremely simple forms in minimalism, while conceptual art, land art, and performance art challenged the idea that there had to be an actual art object involved at all.

Key artists:
Alexander Calder (1898–1976), Wassily Kandinsky (1866–1944), Le Corbusier (1887–1965), Kasimir Malevich (1878–1935), Joan Miró (1893–1983), Piet Mondrian (1872–1944), Amedee Ozenfant (1886–1966), Bridget Riley (1931–).

ABSTRACT EXPRESSIONISM

Abstract expressionism was an art movement that flourished in the United States, mainly in New York, from the late 1940s to the early 1960s. During the 1950s it also spread to other countries, becoming one of the major international movements of the period. It dominated American art until the emergence of pop art in the 1960s.

The term in fact covers a number of different but related styles. Typically, abstract expressionist paintings are abstract works painted in a bold, vigorous style that is meant to have a direct and powerful emotional impact. This is achieved through such means as strong colors, size (many abstract expressionist paintings are very large), dynamic forms, and very energetic —at times almost violent—painting techniques; some artists dripped, splashed, or smeared paint onto their canvases in a form of painting sometimes known as action painting.

Abstract expressionism brought together two distinctive developments of 20th-century art: abstract art and surrealism. Abstract art had freed artists from the need to create recognizable images. But whereas many early abstract paintings (notably those of Piet Mondrian and Kasimir Malevich) are often well-constructed works (with subtle color harmonies, clear compositions, and simple, well-defined geometrical shapes), abstract expressionist paintings are dynamic and often unstructured, the forms often crude, complex, or undefined. This shows the direct influence of surrealism (many European surrealists had fled to New York just before World War II).

The surrealists believed that the mind has two parts: a conscious level, that of everyday thought; and an unconscious level, a deep well of powerful, unpredictable, and disruptive forces that usually remain hidden (a world usually glimpsed only in our dreams). They argued that artists should ignore the everyday world and try to release the intense and unpredictable energies of the unconscious. Abstract expressionists attempted to do this by painting in a spontaneous way, relying heavily on improvisation and on chance effects (such as those created by splashing or dribbling paint). They saw their paintings as passionate assertions of individual freedom and creativity.

Although they shared this common starting point (abstraction plus surrealism), most abstract expressionists developed their own distinctive styles. The figures in Willem de Kooning's paintings, for example, are not completely abstract, and the large areas of subtly modulated color in Mark Rothko's canvases often produce a mood of quiet contemplation rather than intense emotion. Some artists, such as Robert Motherwell, concentrated on producing a few simple, monumental forms.

Abstract expressionism is particularly important in the development of modern art because it was the first truly American art style (albeit with European sources) that was of international importance. It had a marked impact on European art, and helped New York replace Paris as the world's most important art center.

Key artists:
Arshile Gorky (1904–48), Franz Kline (1910–62), Willem de Kooning (1904–97), Lee Krasner (1908–84), Robert Motherwell (1915–91), Barnett Newman (1905–70), Jackson Pollock (1912–56), Mark Rothko (1903–70).

Figure in Interior by **Willem de Kooning**
1955. Pastel on canvas. 26 1/2 x 33 1/4 in (67 x 84.5 cm). Private collection.

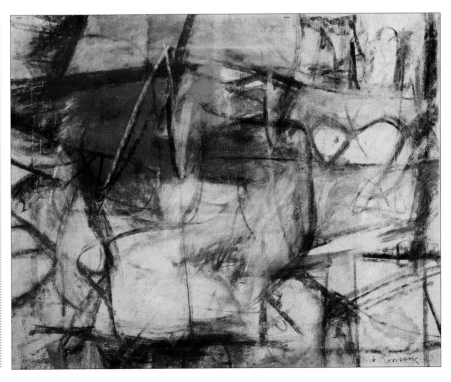

ART NOUVEAU

Art nouveau was a "new art" that was intended to leave behind the cluttered, imitative style of 19th-century art and design. Its hallmarks were long, flowing, sinuous, and asymmetric lines based on natural forms. It was developed initially in England, where the designer William Morris had created an industry of highly crafted, handmade goods—wallpaper, furniture, textiles—in reaction to the shoddy workmanship of mass-produced articles. His Arts and Crafts Movement became linked with art nouveau, which took its name from a gallery, Maison Art Nouveau, in Paris, which opened in 1895.

Liberty & Company, a store established by Arthur Lasenby Liberty in London, did much to promote the modern style in continental Europe. Liberty's textiles, printed with art nouveau designs, were so successful that he also opened a store in Paris in 1889. Liberty style included a whole range of domestic wares in silver and pewter, and became the last word in fashionable living.

Art nouveau was primarily a force in the applied arts—particularly in graphic and interior design, and in jewelry- and furniture-making—rather than in the fine arts. Although its center was in Paris, other countries adopted the art nouveau style: in Italy it was called Stile Liberty after the store, in Germany Jugendstil (youth style), in Spain modernista, and in Scotland it was dubbed Glasgow style.

Japanese prints were very popular in Europe at the time, and their linear patterns greatly influenced many art-nouveau artists. The illustrator Aubrey Beardsley evolved a delicate yet dynamic manner of illustrating in black

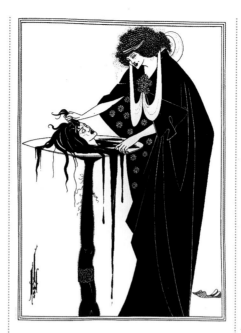

The Dancer's Reward by Aubrey Beardsley *1894. Brush and ink illustration for* Salome *by Oscar Wilde (published 1894).*

and white. His assured, distinctive style influenced such turn-of-the-century artists as Gustav Klimt. At the same time Henri de Toulouse-Lautrec and Alphonse Mucha used expressive lines to elevate poster art to a new plane. Mucha's use of repeating feather, flower, and bird motifs echoed wallpaper and textile designs.

The French designer René Lalique adopted art nouveau, too, displaying his glass and jewelry designs at the World's Fair in Paris in 1900. Lalique experimented with unusual materials such as horn and tortoiseshell, and used colorful stones such as jade, agate and chalcedony; he also revived the art of enameling. In the United States, Louis Comfort Tiffany was making similar experiments with semiprecious stones in fruit and flower shapes. He led design in the field of making glass for windows, lamps, and vases, using a method he

spent 30 years perfecting. By blending different colors Tiffany was able to imitate natural forms such as peacock feathers or plants.

The new art influenced architecture as well; in 1892–93 Belgian Victor Horta created Hôtel Tassel in Brussels, one of the first art-nouveau buildings in continental Europe. The French architect and designer Hector Guimard created plant forms in cast iron to mark the Paris Metro subway entrances. In Scotland architect Charles Rennie Mackintosh's designs included the Glasgow School of Art (1897–1909). Mackintosh often designed many elements of interiors as well, from chairs to cutlery.

In the German-speaking countries the reactions to art nouveau were more restrained, placing comfort above decoration. An artists' colony was set up in Darmstadt, Germany; the architect Peter Behrens designed all but one of the buildings there. Barcelona in Spain was another pocket of art-nouveau architecture, realized in a individualistic way by Antoni Gaudí in works such as Park Güell (1900–14).

Art nouveau was not universally admired, acquiring nicknames such as Bandwurmstil (tapeworm style), and Stile Nouille (noodle style). World War I brought an end to this opulent style, which in the postwar era made way for art deco and De Stijl.

Key artists:
Aubrey Beardsley (1872–98), Peter Behrens (1868–1940), Hector Guimard (1867–1942), Victor Horta (1861–1947), René Lalique (1860–1945), Charles Rennie Mackintosh (1868–1928), Louis Comfort Tiffany (1848–1933).

ASHCAN SCHOOL

The Ashcan school was the name given to a group of American urban realist painters who were active in New York in the years before World War I. The name was not, in fact, applied to these artists until 1934, when Alfred Barr and Holger Cahill wrote *Art in America in Modern Times*. In addition, the Ashcan school was only a loose association of a number of artists.

The Ashcan school is often confused with another artistic group working at this time called The Eight. The confusion in part lies in the fact that some of the Ashcan school members had also been members of The Eight, a group led by Robert Henri. The Eight had come together in 1907 when the National Academy of Design rejected the works that John Sloan, William Glackens, and George Luks had submitted for exhibition. Henri, who became the dominant personality of The Eight, withdrew his own accepted works from the show. The Eight (which also included Everett Shinn, Arthur B. Davies, Maurice Prendergast, and Ernest Lawson) then organized their own independent exhibition in 1908.

While the other members of The Eight developed independently as artists, Henri, Sloan, Luks, Glackens, and Shinn continued their association. Henri encouraged his four colleagues to give up their jobs as illustrators on *The Philadelphia Press* and become serious painters. Their newspaper backgrounds, together with Henri's belief that art should be as "clear and as simple and sincere" as possible, encouraged the group to explore the rich subject matter provided by everyday, urban life in the United States.

They were called the "Revolutionary Black Gang" by critics, both because of

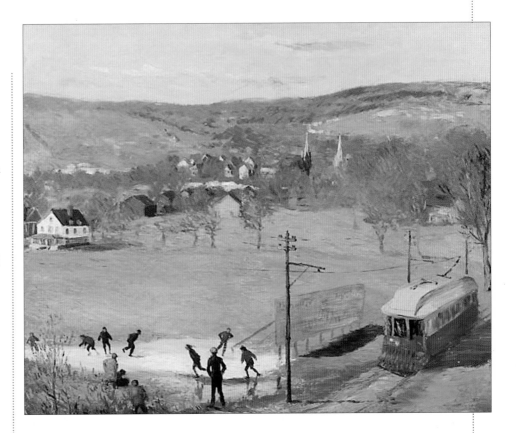

***West Hartford* by William Glackens**
1907. Oil on canvas. 26 x 32 in (66 x 81 cm).
Wadsworth Atheneum, Hartford, CT.

the type of subject matter that they chose (the urban environment), and because some of the artists used a dark-toned palette and vigorous brushwork. The Ashcan painters were reacting against impressionism, and their work marked a return to realism. Not all the Ashcan school artists painted in this style, though: Glackens was less concerned with gritty, urban realism than with presenting modern life as a colorful spectacle. While Luks produced many paintings of cleaning women and clowns, Sloan found his subjects in people crossing the busy streets or seated in cafés. In contrast to this "low-life" imagery, Shinn preferred scenes from the theater and music hall.

Making modern American life the subject of art attracted other artists into the Ashcan school, in particular Glenn Coleman and Jerome Myers. However, the outstanding painter of the Ashcan school is George Bellows: his powerful paintings captured the movement and

action of boxers fighting, of children swimming, and of the river traffic.

It was not until the 1930s that social realism became a major force in American art. The Ashcan school's interest in contemporary life in the United States encouraged the American scene painters, such as Edward Hopper and Charles Burchfield, and regionalists, such as Thomas Hart Benton and Grant Wood, to break free from the influence of Europe and develop a truly American art.

Key artists:
George Bellows (1882–1925), William Glackens (1870–1938), Robert Henri (1865–1929), George Luks (1867–1933), Jerome Myers (1867–1940), Everett Shinn (1873–1953), John Sloan (1871–1951).

AVANT-GARDE

The term "avant-garde" has been widely used in discussions about modern art, particularly in the years following World War II. Over time the term has meant a number of things, but its most accepted use today is to refer to any group of artists that considers itself to be in some way innovative, or at the forefront of change, ahead of the rest of the art world.

In general, avant-garde art is art that is deemed to have (1) redefined artistic conventions—"broken the rules"—(2) used new techniques and tools (for example, the cubists and collage, or Jackson Pollock and his elimination of the easel to support the canvas), and (3) redefined the nature of the "art object" (such as Marcel Duchamp's "readymade" art; pop art combines; and conceptual art's activities, events, and documentations).

Avant-garde is actually a military term, used to describe the front ranks of an army (the vanguard) advancing into battle. Avant-garde was first applied to art in the 1820s in France, when the political theorist Henri de Saint-Simon saw art as having a key role to play in the process of freedom. Instead of relying on an elite or ruling class to exercise leadership in society (and in matters of art, such as taste), Saint-Simon proposed that artists, the new industrialists, and the modern technical specialists should join together to aid social progress and build a new society. Saint-Simon's idea of the avant-garde essentially meant an art that was committed to social and political change. This idea stood in contrast to the prevailing idea that art existed for its own sake: "*l'art pour l'art.*"

In the years following World War II, avant-garde began to mean the very

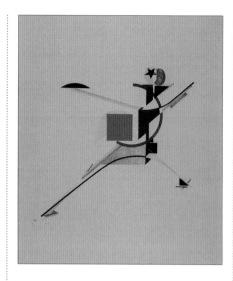

New Man from *Victory Over the Sun* by El Lissitzky *1923. Color lithograph on paper. 15 x 10¹⁄₂ in (38 x 27 cm). Philadelphia Museum of Art, Philadelphia, PA.*

opposite of what Saint-Simon had suggested. Avant-garde now meant art for art's sake. The American critic Clement Greenberg, a leading writer on contemporary art at the time, defined avant-garde art as being responsible only to the values of art. Avant-garde art did not require any justification for its existence: art was "independent" and "autonomous." Avant-garde art for Greenberg did not need ideas or subject matter, but should be interested only in exploring the formal qualities of art. Avant-garde art was therefore unrelated to society at large; its only relationship was with other kinds of art. Greenberg was essentially using the term avant-garde to describe the modern movement—begun in 19th-century France by Edouard Manet and culminating in the abstract works of Pablo Picasso, Piet Mondrian, Paul Klee, and Wassily Kandinsky.

In the postwar period in the United States, Greenberg saw his definition of

the avant-garde (and the continuation of the artistic tradition that led to abstraction) in the personal, subjective, abstract expressionist works of artists such as Jackson Pollock and Mark Rothko, and in works by the post-painterly abstractionists like Morris Louis and Kenneth Noland, who emphasized pure, flat color.

In the 1960s, in the wake of social, political, and intellectual changes, many artists and critics sought to return avant-garde to its original (Saint-Simon) use. In this period, the avant-garde came to mean those artistic groups that, in response to World War I and the Russian Revolution, sought to overcome the separation of art and life, and art and politics. The leading avant-garde movements were acknowledged as dadaism, constructivism, and surrealism, along with related movements such as cubism, expressionism, and futurism.

Today, some critics contend that the avant-garde has "disappeared" with the emergence of postmodernism. Nonetheless, many contemporary artists, even if they do not use the term avant-garde, keep alive the tradition of shocking—even, disgusting—their audiences: Damien Hirst's animals preserved in tanks of formaldehyde (as in *The Physical Impossibility of Death…*, 1991), and Marcus Harvey's giant portrait of child murderer Myra Hindley (1995) are two examples.

Key artists:
Marcel Duchamp (1887–1968), Wassily Kandinsky (1866–1944), Paul Klee (1879–1940), El Lissitzky (1890–1941), Edouard Manet (1832–83), Piet Mondrian (1872–1944), Pablo Picasso (1881–1973), Jackson Pollock (1912–56), Mark Rothko (1903–70).

BARBIZON SCHOOL

The Barbizon school was a group of French landscape painters who settled in the small village of Barbizon near the forest of Fontainebleau in the late 1840s. Inspired by the English landscapists John Constable and Richard Bonington, and by the 17th-century Dutch landscape tradition, their main aim was to paint directly from nature. They conveyed the momentary effects of nature with looser, more sketchy brushwork than had been seen previously. Their approach was in direct opposition to the conventions of contemporary academic painting.

The leader of the group was Théodore Rousseau, who first went to Barbizon in 1836 as a retreat from Paris. By 1848 he had settled there. He was regularly joined by artists such as Charles-François Daubigny, Narcisse Virgile Diaz de la Peña, Jules Dupré, Constant Troyon, Jean-François Millet, and Camille Corot. In Barbizon they found a tranquil, rustic landscape where they could be in close communion with nature, while remaining in touch with current art movements in Paris.

The working methods of the Barbizon school were to make sketches or studies in the open ("en plein air"), in order to capture the play of light and changing weather. They would then reproduce a perfect image in paint in their studios, while all the time keeping in mind what Rosseau called "the virgin impression of nature."

The Barbizon painters were united in a common aim, yet each applied to this notion their own individual styles. Rousseau, a talented draftsman, strove to combine meticulous detail with an atmosphere of stillness and harmony in his paintings. He successfully achieved these aims in many beautifully observed

landscapes and wooded scenes such as *The Edge of the Woods* (1854), and *A Group of Oaks near Barbizon* (1852). The paintings of his colleague, Diaz de la Peña, are more restless, displaying a freer technique with often thickly applied paint. Spots of light are highlighted with dabs of white pigment and bright color—a technique which was of particular inspiration to the later impressionist painters.

Charles-François Daubigny was a great exponent of painting *en plein air*, some of which he did from a houseboat while traveling the local rivers, assured of peace and solitude. Daubigny was preoccupied with capturing fleeting aspects of nature, and the concepts of light and atmosphere took on a new dimension in his work. Jean-François Millet was closely associated with Barbizon from 1849, and remained in the village until he died. However, only in his late works, such as *Spring* (1868–73), did pure landscape play a dominant role, emphasized by dramatic

***Spring* by Jean-François Millet** *1868–73. Oil on canvas. 33¾ x 43¾ in (86 x 111 cm) . Musée d'Orsay, Paris.*

light and atmospheric effects. The landscapes of Camille Corot have a soft, poetic quality, and glow with a delicacy of technique achieved by using thin, translucent paint washes.

In their methods and subject matter, the painters of Barbizon helped to lay the foundations of impressionism. They challenged the traditional values of academic painting with respect to what constituted a direct sketch, and what was a finished studio painting.

Key artists:
Camille Corot (1796–1875), Gustave Courbet (1819–77), Charles-François Daubigny (1817–78), Narcisse Virgile Diaz de la Peña (1807–76), Jules Dupré (1811–89), Paul Huet (1803–69), Jean-François Millet (1814–75), Théodore Rousseau (1812–67), Constant Troyon (1810–65).

BAROQUE

Baroque was the dominant style in European art for most of the 17th century and up until the mid-18th century, and affected painting, sculpture, and architecture. The origin of the term baroque is uncertain, but possibly derives from a Portuguese word, *barroco*, meaning an irregularly shaped pearl.

Baroque art originated in Rome, where it built on the achievements of the High Renaissance in reaction against the artificiality of 16th-century mannerism. Baroque had strong links with the Catholicism of the Counter-Reformation, and called for a clear message in religious art. Artists responded with a dynamic new style that had strong emotional appeal.

Baroque art is dramatic, exuberant and theatrical; its most obvious characteristics are dynamic movement and exaggerated emotions. Intended to overwhelm the spectator, and to appeal to the mind through the emotions, it is visually easy to read. This is achieved by various means: a concern for realism with solid form emphasized by the use of strong color and contrast; the depiction of the moment of highest drama, with effective use of movement and actions to tell the story; a love of splendor and extravagance, and a widespread use of "illusionism"—the art of convincing the spectator that something is "real" when it is a pictorial representation.

At the head of the baroque tradition in painting are Michelangelo Merisi da Caravaggio, and Annibale Carracci. Caravaggio initiated a new, startling realism, and an unconventional treatment of religious themes. He used laborers and peasants as models for his figures of saints, refusing to idealize

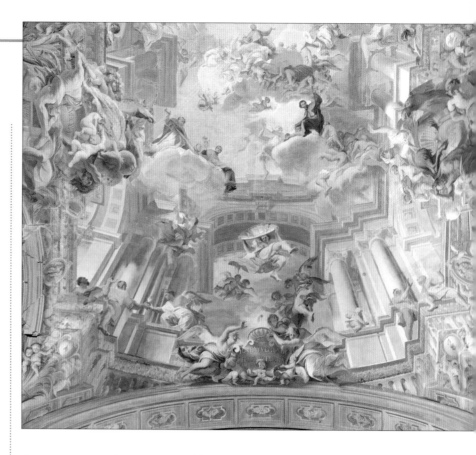

them in any way. Caravaggio would even paint dirty feet and drapery to emphasize their "realism." Another innovation was his use of light and dark, which became a dominant feature of baroque art. A harsh direct light from a single source would pick out his figures, in sharp contrast to the darkness of the background. He also chose to depict the moment of highest drama as, for example, in *The Conversion of Saint Paul* (1600–01), where he shows Paul being flung to the ground, blinded by a sudden light from heaven.

Annibale Carracci and his brothers revived the Renaissance concern with drawing from life, and their art was based on a more solid, naturalistic approach. In its maturity Annibale's heroic style of fresco decorations for the Farnese Palace in Rome possesses a highly theatrical quality, full of the movement, high spirits, and flowing rhythms that characterize baroque art.

The baroque style reached its peak in c1630–80, a period known as the

The Glorification of Saint Ignatius by **Andrea Pozzo** *Detail. 1691–94. Ceiling fresco. Sant' Ignazio, Rome.*

high baroque, which was dominated by the outstanding genius of Gianlorenzo Bernini. Famous for his design and building of the Piazza and Basilica of Saint Peter's in Rome, Bernini successfully fused together sculpture, architecture, and painting. His sculpted figures are shown in twisted, contorted poses, halted in mid-action, such as in *Apollo and Daphne* (1622–25), which depicts the moment when Daphne is transformed into a laurel tree.

Bernini's talents were diverse, and he used a wide range of materials, from colored marble to bronze, to achieve his desired effects. Perhaps the fullest expression of this diversity can be seen in his *Vision of the Ecstasy of Saint Theresa* (1647–52) in which the saint is portrayed at the moment of mystical epiphany, drawing the spectator in to share the intensity of the experience. Bernini's handling of marble to create

BAUHAUS

the smooth, rippling effects of the drapery, and of gilded metal to create an illusion of rays of light is masterful.

During the 17th and 18th centuries the tradition of illusionistic ceiling painting grew in popularity, in the work of artists such as Pietro da Cortona at the Barberini Palace, and later of Andrea Pozzo at San Ignazio in Rome, where the eye is directed upward to a host of spiritual figures spiraling up toward the heavens. These overwhelming paintings project into visual terms what might be seen by the eye of the imagination.

The baroque style took its firmest roots in Catholic countries such as Italy, Spain, Austria, and southern Germany. In the north of Europe, artists generally did not adopt the style, although a notable exception was Peter Paul Rubens in Catholic Flanders. Inspired by his formative years in Italy, Rubens's paintings are a triumph of energy, interlocking curves, rich color, and exuberance. Another exception was in France, where King Louis XIV chose the baroque style as a means of expression of pomp, display, and the glory of the monarchy at his palace at Versailles.

By the mid-18th century the baroque was gradually developing into the more refined and delicate lines of the rococo style.

Key artists:
Gianlorenzo Bernini (1598–1680), Francesco Borromini (1599–1667), Michelangelo Merisi da Caravaggio (1571–1610), Annibale Carracci (1560–1609), Pietro da Cortona (1596–1669), Baldassare Longhena (1598–1682), Andrea Pozzo (1642–1709), Peter Paul Rubens (1577–1640).

The Bauhaus was a school of art, architecture, and design in Germany between the world wars. So innovative and distinctive were its products and working methods that the school's name, "Bauhaus," (translating roughly as "building house") came to stand for a new, clean, functional, modern style.

Many items we use today, such as stackable chairs, adjustable desk-lamps, and even some forms of typeface, originated in the workshops of the Bauhaus. Teachers and students were committed to exploring new ways of producing well-designed objects that were elegant yet practical, and could be produced easily and economically. The development of this modern style was related to political ideals; the Bauhaus members genuinely hoped that by reforming architecture and design on a mass scale they could improve the lives of ordinary working people.

The school was established in 1919 in the old German city of Weimar. Its director was the architect Walter Gropius. Idealistic and ambitious, Gropius first envisaged the Bauhaus as a kind of medieval community of craftsmen living and working together in harmony. The idealism of the Bauhaus was always important, but as practical concerns took over and the scale of its projects grew, efficiency, economy, and a productive relationship between art and technology became the key principles.

In the early years the school was poorly equipped, and a little chaotic. Even so, the students were able to learn many skills. There were workshops for textiles, ceramics, wall-painting, wood-work, metalwork, printing, and other fields of design. As Gropius employed

Head **by Oscar Schlemmer** *c1931. Oil on canvas. 13 x 15 in (33 x 38 cm). Stedelijk Museum, Amsterdam.*

more and more prestigious staff to teach there, a real sense of progress and innovation developed.

Among those who joined the staff was the painter Wassily Kandinsky, who impressed on students the importance of color and form. He and other members were influenced by Russian constructivism, which seemed to offer an ideal for a new "collective" art. Indeed in Bauhaus products, especially the posters, we see the emphasis on geometry, simplicity, and primary colors that characterized constructivism and the Dutch De Stijl movement, another key influence.

Other artists who taught at the school included Paul Klee, Oskar Schlemmer, and the Hungarian László Moholy-Nagy. Schlemmer was an extremely versatile member; he began at the mural-painting and sculpture workshops, but moved to the theater workshop, where he revitalized the students' ideas about dance, stage sets, costumes, and the human body itself. Soon, the extraordinarily innovative Bauhaus theater performances, such as

Schlemmer's *Triadic Ballet* (1923), were a central part of the school.

An important feature of the Bauhaus was its international spirit. Staff and students came from many different countries, and the ideas they developed were for a new international modern style that could be universally applied. The local government, suspicious of the Bauhaus's unconventionality, cut the school's funding. Eventually it closed.

In 1925 the Bauhaus moved north to the city of Dessau; the move seemed to breathe new life into it. Gropius designed a building to house the school, including accommodation for staff and students. Utilizing the latest building technologies and materials, featuring huge expanses of glass, and a light, airy structure, the building remains a classic of modern architecture today.

In 1926 Gropius summarized the aims of the Bauhaus. He wrote that any object produced for modern life "must perfectly serve its purpose: it must function practically, must be cheap, durable, and beautiful." This emphasis on "functionalism" came to form the basis of modern principles of design and architecture. Gropius, for example, led housing projects for low-income families, who were provided with light, heating, water, and communal facilities;

while Herbert Bayer produced radically modified typefaces, lettering that did away with unnecessary flourishes and was clear, bold, and easy to read.

Problems began to develop after 1927, when architect Hannes Meyer became director of the Bauhaus. Meyer was strict, controversially political, and his priority was architecture. Many staff and students left the school feeling that the original community spirit was now lost. Meyer was replaced by Ludwig Mies Van der Rohe in 1930. Mies, a brilliant designer, preferred working for rich clients, and his authoritarian behavior made him unpopular.

By the early 1930s the Bauhaus was facing difficulties. Nazism was gathering strength, and the Nazis hated anything modern or international. Mies Van der Rohe managed to preserve the school for a short time, in Berlin, before it was closed for good in August 1933. Many Bauhaus members emigrated to escape persecution. The school's reputation now became international: it had succeeded in forming a new style and philosophy for art, architecture, and design in the modern world.

Key artists/designers:

Herbert Bayer (1900–85), Marcel Breuer (1902–81), Walter Gropius (1883–1969), Wassily Kandinsky (1866–1944), Paul Klee (1879–1940), Hannes Meyer (1889–1954), Ludwig Mies Van der Rohe (1886–1969), László Moholy-Nagy (1895–1946), Oskar Schlemmer (1888–1943).

The Bauhaus by Walter Gropius *1925–26. Steel, glass, and brick. Dessau, Germany.*

BLAUE REITER, DER

The German Franz Marc and the Russian artist Wassily Kandinsky set up the group known as Der Blaue Reiter, or The Blue Rider, in Munich in 1911. They choose the name because, for Marc, blue evoked spirituality, and the horse was one of his favorite subjects. The rider was a motif they took from folk art to symbolize art's leap into the future.

In December 1911 the group mounted an exhibition. This included works by the German August Macke, a number of French artists, and even by the composer Arnold Schoenberg. It showed that the Blaue Reiter aimed to link artists whose style differed but who all wanted to express the intimate, more spiritual side of human nature.

At this time Kandinsky was moving toward abstraction; his pictures swirled with shapes and colors, linked by expressive dark lines. Gabriele Münter, another member, took as her subjects landscapes and still lifes; she was also interested in the Bavarian folk art tradition of painting behind glass.

Marc painted animals, believing they represented what was pure and virtuous. For him, colors had different meanings. "If you mix red and yellow to make orange, you turn passive, feminine yellow into a Fury," he said. August Macke, who became a core member of the group, was also interested in the energy given off by color. He wanted to celebrate everything in nature: "sunlight and trees, plants, people, animals, flowers, and pots…".

The second and last Blaue Reiter exhibition took place in February 1912. An international show, it publicized work by French, Russian, and German artists. Paul Klee also exhibited with

BRÜCKE, DIE

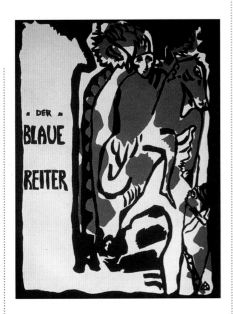

Cover for *Der Blaue Reiter* almanac by Wassily Kandinsky *1911. Ink and watercolor on tracing paper. 8³⁄₄ x 8¹⁄₂ in (28 x 22 cm). Lenbachaus, Munich.*

the group. The association proved important for Klee's development: he had always confined himself to working in black and white, but on a visit to Tunisia with Macke in 1914 he was inspired to use color in his art.

The Blaue Reiter artists produced an almanac in which they stated their aim "to push back the existing limits of artistic expression." The almanac included articles on painting, theater design, and music, and illustrations from folk and Oceanic art, Japanese prints, and children's drawings.

In the three years of their association the Blaue Reiter artists produced some of the most important paintings of the 20th century, and Kandinsky and Klee emerged as two of modern art's most important figures.

Key artists:
Wassily Kandinsky (1866–1944), Paul Klee (1879–1940), August Macke (1887–1914), Franz Marc (1880–1916), Gabriele Münter (1877–1962).

Four young German students founded the revolutionary art group called Die Brücke, or The Bridge, in 1905. Ernst Ludwig Kirchner, Erich Heckel, Karl Schmidt-Rottluff, and Fritz Bleyl met while studying architecture in Dresden, and then banded together to create a new kind of art. They rejected the values of their own highly conformist society, whose art was— they believed—conventional and academic. They saw themselves as leading youth into a brighter future, stating, "We want to wrest freedom for our actions and our lives from the older, comfortably established forces." The name of their group derived from a remark by the 19th-century German philosopher Friedrich Nietzsche, who said, "What is great about man is that he is a bridge and not a goal."

These artists wanted to express what they felt as intensely and directly as possible, and to do this they used exaggerated lines and pure color. They had little art training, but believed so strongly in themselves and their aims that they felt free to experiment. For example, they mixed gasoline with oil paints to make them dry more quickly and create a matt effect. They found inspiration in the soul-searching work of Edvard Munch, and in Vincent Van Gogh's vibrant use of color, as well as in the forms of African and Polynesian sculpture.

To convey their own spontaneity, the members of Die Brücke made endless, quick drawings of their subject, and became skilled in watercolor, a medium suited to speedy execution. Nudes in interiors and in open-air settings were favorite subjects, along with circus and music-hall scenes. They rediscovered the potential of the

woodcut, whose strong contrasts of black and white could be used to disturbing effect. They produced regular portfolios of woodcut prints to make their work known to as many people as possible: they wanted to inspire others to action. Other artists joined them, including Max Pechstein, Emil Nolde, and Otto Müller.

The first Die Brücke exhibition was held in 1906 and heralded the arrival of German expressionism. Die Brücke went on to hold more than 20 further exhibitions. In 1911 the group moved to Berlin. The hectic life in the city added a further edge of decadence and angularity to their work, but growing tensions between the members led to Die Brücke's disbanding in 1913.

Key artists:
Fritz Bleyl (1880–1966), Erich Heckel (1883–1970), Ernst Ludwig Kirchner (1880–1938), Karl Schmidt-Rottluff (1884–1976).

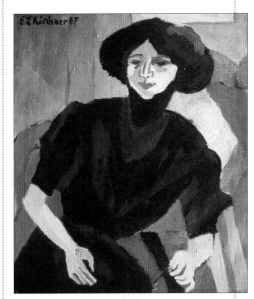

***Gerti* by Ernst Ludwig Kirchner** *1907. Oil on canvas. Dimensions unavailable. Private collection.*

BYZANTINE

The art that was produced during the time of the Eastern Roman Empire is known as Byzantine. This period began in AD 330 when the Emperor Constantine (the first Christian emperor) transferred the capital of the Roman Empire from Rome (in the West) to Byzantium—later renamed Constantinople—in the East. It ended in 1453 when Constantinople was conquered by the Turks and became Istanbul. By that time the Renaissance was underway in the West and the Byzantine style had spread from Constantinople, through southern Italy and the Balkans, into Russia.

Byzantine art was primarily a religious art, and Byzantine artists were the voice of orthodox Church dogma. Their function was to translate the teachings of the Church into the language of art in order to instruct the people. Byzantine artists did not attempt to pursue free individual expression or interpretation: subjects, attitudes, attributes, and expressions of their figures were all predetermined according to traditional schemes. Christ was commonly depicted as the all-powerful ruler of the universe (*pantocrator*, in Greek), and portrayed high up in the domes of churches. Figures were shown frontally and were flat and stylized, their faces without expression, giving them a somewhat remote and supernatural quality.

The best and most spectacular examples of Byzantine art are in the mosaic decorations of churches. Some of the most splendid examples are at San Vitale in Ravenna, Italy, which were produced under the patronage of the Emperor Justinian, an enlightened patron of the arts who built on a huge scale during the sixth century. Large areas of the interior are completely covered with exquisite mosaics, and its surfaces shimmer with gold and marble.

The tradition of fresco painting was also employed during this period; major schemes still survive in Greece and Turkey. Of particular beauty are the frescos at the Kariye Camii in Istanbul (1315–21), which are a fine example of late Byzantine art. Also typical of Byzantine art are icons: small, portable panel paintings, usually featuring Christ, the Virgin and Child, or saints, and used in private worship.

Key sites:
San Vitale, Ravenna, Italy; Cefalu Cathedral, Sicily, Italy; Church of the Dormition of the Virgin, Daphni, Greece; Kariye Camii, Istanbul, Turkey; Hagia Sophia, Kiev, Ukraine.

Cristo Pantocrator (All-powerful Christ)
c1148. Apse mosaic. Cefalu Cathedral, Sicily.

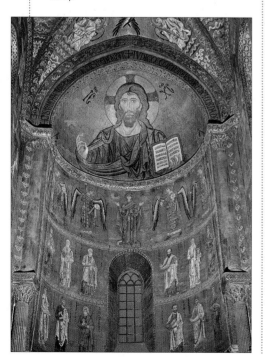

CLASSICISM

Classicism is a term used to describe art that follows a pure esthetic ideal rather than one that pursues a strongly individual expression. It evokes the qualities of order, harmony, and clarity associated with the art of ancient Greece and Rome. Classicism should not be confused with "classical," which refers to a specific period in Greek culture, or with "classic," which means the best or most representative example of its kind. Nor should it be confused with neoclassicism, an art movement in the late 18th century that consciously set out to recreate the spirit of Greek and Roman art.

Classicism emerged during the 17th century as an alternative to the flamboyance of the baroque style. It began in response to the discovery of the antique (the physical remains of the Greek and Roman world), and the frescos of Michelangelo Buonarroti and Raphael; Raphael, in particular, was revered as an artist whose work encompassed the ideals of harmony, clarity, and balance. Annibale Carracci laid the foundations for a trend toward classicism in his Farnese Gallery ceiling frescos, in which he fused elements of the High Renaissance masters with elements of the antique. Artists such as Il Guercino, Guido Reni, Domenichino, Andrea Sacchi, and Pietro da Cortona also began to adopt a more classical approach. Compositions became clearer and less cluttered, and featured fewer figures more spaced out, and there was a change to a mood of calm simplicity.

Nicolas Poussin, a Frenchman who spent most of his working life in Italy, gave classicism a definitive form. He developed a style, characterized by a clarity of composition, intellectual

CONCEPTUAL ART

***Santa Susanna* by François Duquesnoy**
1629–33. Marble. Life size. Santa Maria di Loreto Church, Rome.

precision, and obedience to the principle that painting should appeal to the mind and not to the eye. He formulated what were to become the central doctrines of the classicism that was later taught in the academies: that painting must depict only noble and serious subjects, and must present them in a clear and orderly manner.

Poussin's working procedure was very methodical, based on many preparatory drawings. He used wax models on miniature stages, so that he could study

lighting and composition in detail. In his paintings movement is restrained, while every gesture and expression is plotted with mathematical exactness.

Another tradition within classical painting was ideal landscape painting. Both Poussin and Claude Lorraine were great exponents in this field. Taking as their subject matter the countryside around Rome, they tried to portray an "ideal classical past." The classical current was surprisingly less strong in sculpture than in painting. Two important and individual sculptors emerged: François Duquesnoy and Alessandro both spent much of their careers in Rome, where they worked in a consciously classical manner.

The classicism established by Poussin later became the opposing artistic trend to Romanticism. France saw the two approaches simultaneously in the 19th century in the fierce rivalry between Jean Auguste Dominique Ingres, the arch classicist, and Eugène Delacroix, the ultimate Romanticist. The climax of Poussin's legacy could be seen when Paul Cézanne, envying his predecessor's clarity of form and structure, sought to "do Poussin again, from nature."

Key artists:
Alessandro Algardi (1598–1654), Annibale Carracci (1560–1609), Paul Cézanne (1839–1906), Pietro da Cortona (1596–1669), François Duquesnoy (1594–1643), Domenichino (1581–1641), Il Guercino (1591–1666), Jean Auguste Dominique Ingres (1780–1867), Claude Lorraine (1600/1604–82), Nicolas Poussin (1594–1665), Guido Reni (1575–1642), Andrea Sacchi (1599–1661).

Conceptual art is the name given to a type of art in which the "ideas" or concepts that a work represents are the essential things. Consequently, the finished work of art—if indeed there is a finished object at all—is not actually seen as an art object, but as a form of documentation of ideas. The expression was first used by the American artist Henry Flynt, but the term "conceptual art" began to be used after Sol LeWitt used it in an article in *Artforum* magazine in 1967. Conceptual art flourished in the mid-1960s and reached its peak in the mid-1970s.

Conceptual art, sometimes also called idea or information art, included a broad range of artistic activities, such as body art (where the artist uses his or her body as the medium for their art), performance art (an artform that combined elements of theater, music, and the visual arts, but not generally involving audience participation), and land art (art that uses the raw materials of the earth—soil, mountains, ice, snow, and so on). What all these tendencies had in common was that they rejected the widespread and deeply held belief that art was made up of individual, unique, permanent, portable, valuable objects.

Instead, in conceptual art, the emphasis was on the idea—ideas in art, about art, in life, and about everything in the world! Conceptual artists believed that such a vast amount of information could not fit easily into a single, portable work, but would be better communicated through a wide variety of media: written documents, video, tapes, movies, photographs, the artists' bodies, and, most often, through language itself. To understand conceptual art "ideas," audiences

CONSTRUCTIVISM

needed a different type of "attention" and had to think about art in a new way. They also had to come to terms with the idea that art did not necessarily exist only in museums and galleries, but could also "happen" in streets, in sports stadiums, in empty warehouses, or even in different cities at the same time. But as most conceptual art was explained through written documents, people could understand the ideas being presented, even if they could not understand them through the art itself.

Conceptual art is seen to have grown out of the activities of dada artist Marcel Duchamp. Duchamp's "readymade"—a store-bought urinal that he signed R. Mutt and called *Fountain*—questioned the status of objects as art, and the way institutions such as museums confer that status on objects. Artists who followed Duchamp in this "questioning" included Robert Rauschenberg. In 1960 Rauschenberg was invited by gallery-owner Iris Clert to show works in an exhibition in Paris. He sent a telegram saying: "This is a portrait of Iris Clert if I say so."

The first artists to be described as conceptual included Douglas Heubler (who, since 1971 has been working on a series in which he aims to photograph "everyone alive"); Joseph Kosuth, and Robert Barry. In 1969 Barry produced

his *Telepathic Piece*, for which he wrote an accompanying document stating that during the exhibition he would try to "communicate telepathically" with the audience in order to create his art. Barry's other activities have included photographing the dispersal of small amounts of invisible, inert gases into the equally invisible atmosphere.

Admirers of conceptual art see such activities as questioning the nature of art and life, and expanding the existing and accepted boundaries of what art is and what an artist is. Those critical of conceptual art condemn it for not demonstrating any perceivable artistic skills. Nevertheless, as a movement, conceptual art grew quickly and has spread across the world: possibly the most famous practitioners have included the German artist Joseph Beuys, and the English duo of "living art," Gilbert and George.

Key artists:
Robert Barry (1936–), Joseph Beuys (1921–1986), Gilbert and George (Gilbert Proesch, 1943– , and George Passmore, 1942–), Douglas Heubler (1924–), Joseph Kosuth (1945–).

Clock (One and Five) by Joseph Kosuth
1965. Clock, photograph, and printed texts on paper. 24 x 114 in (61 x 290 cm). Tate Gallery, London.

Constructivism was a movement in abstract art that began in Russia around 1914 and reached its peak in the years following the Russian Revolution of 1917. When some of the main protagonists of constructivism, such as Naum Gabo, Antoine Pevsner, and El Lissitzky, left Russia in the early 1920s, they took their ideas with them and constructivism spread to the rest of Europe.

The constructivists believed that artists should constantly try to discover new forms for art, because life itself was always changing. Art for the constructivists had to reflect the times, and their time was the new "machine age," and a period of social and political revolution. Their art is, therefore, characterized by the use of industrial materials such as glass, metals, and the recently developed plastics such as celluloid. Their three-dimensional works, for example, were made out of separate components that were assembled, much like pieces of engineering, into "constructions" rather than traditional sculptures.

The father of constructivism was Vladimir Tatlin, who took as his slogan, "Art into Life." As well as teaching wood and metal fabrication, Tatlin also worked in ceramics, designed functional worker's clothing, created designs for the theater and movie theater, and even invented the "Letatlin," a human-powered flying machine that was a combination of a glider and a bicycle. Tatlin's most famous work, and the best example of his idea that constructions were "real materials in real space," was his *Monument to the Third International*. With a projected height twice that of the Empire State Building, due to

Construction in Space: Spheric Theme by Naum Gabo *1969. Stainless steel and cor-ten steel. 96 x 96 in (730 x 730 cm). Empire State Plaza Art Collection, Albany, NY.*

material shortages it never progressed beyond a wooden model exhibited in 1920. Nevertheless, it became the symbol of Soviet constructivism.

Like Tatlin, Alexander Rodchenko and El Lissitzky also worked in many fields, including graphic design, architecture, film, and photography. Painting and sculpture were not abandoned, but the constructivists saw these activities not as ends in themselves, but as ways of working toward architectural or industrial projects. El Lissitzky called his paintings "Prouns," an abbreviation of the Russian phrase meaning "new art objects." Lissitzky described Prouns as being halfway between painting and architecture.

In 1920 two brothers, Antoine Pevsner and Naum Gabo, published

their "Realist Manifesto," in which they set out the basic principles of constructivism. They were in favor of pure, abstract art, but by this time the official policy in the Soviet Union increasingly insisted that art was either social realist, or was channelled into "socially useful" work such as industrial design. While Tatlin placed his art in the service of Russian revolutionary politics, Pevsner and Gabo refused to do so. Gabo lived in Germany, France, then England, and finally settled in the United States.

In Paris in 1931, Pevsner and Gabo became the founding members of abstract-creation, an international movement of abstract artists whose members included Wassily Kandinsky, Piet Mondrian, Jean (or Hans) Arp, and the English artists Ben Nicholson and Barbara Hepworth. In the spirit of constructivism, these artists all practiced the type of abstract art that was constructed from completely nonrepresentational, often geometrical elements.

Key artists:
Jean (Hans) Arp (1887–1966), Naum Gabo (1890–1977), Barbara Hepworth (1903–75), El Lissitzky (1890–1941), László Moholy-Nagy (1895–1946), Ben Nicholson (1894–1982), Antoine Pevsner (1886–1962), Vladimir Tatlin (1885–1953).

CUBISM

"A new way of representing the world," was how the artist Juan Gris described cubism, a radical movement that took off in Paris in the early years of the 20th century. Its leaders were Pablo Picasso and Georges Braque, but at the time they did not see themselves as forging a coherent style. Together they abandoned traditional methods of depicting something from a single viewpoint. Instead they wanted to show multiple viewpoints, so that an object would look as though it were being seen from many angles at once.

Picasso's *Les Demoiselles d'Avignon* (1907), which is considered the first cubist painting, shows figures that are fragmented and flattened in parts. The work has a conflicting use of shading to defy perspective. When Braque first saw this painting he was fascinated; it inspired him to paint a large nude in this style. In 1908 Braque submitted some landscapes in this style to the Salon d'Automne, Paris's annual modern art show. They were rejected because the painting seemed to made up of cubes. The works were shown later that year, and the description and its implied criticism were repeated, and so "cubism" entered the language.

The meeting of Braque and Picasso led to a period of intense collaboration between them. Their understanding was such that Braque described them as "mountaineers roped together;" at this stage, from about 1910 to 1912, their works can be difficult to tell apart. The phase is sometimes called analytical cubism, because they were intent on analyzing forms. Both artists were influenced by Paul Cézanne, who conveyed solidity through patches of color rather than conventional shading. Picasso was also interested in African

sculpture, which used elongated, angular forms. With Braque he embarked on a series of monochrome still lifes. They selected everyday objects from their studios—newspapers, musical instruments, African masks—and represented them as a series of geometric shapes, as if their three-dimensionality had been flattened and reassembled. These still lifes present no sense of light and shade, no realistic background, and show the artist's idea of what he was looking at, yet it is still possible to decipher the subject.

Braque was the first to introduce lettering to his work, and experimented with mixing sand and sawdust with paint. Picasso made the first cubist collage, using pieces of paper glued together. This marked a decorative and colorful stage called synthetic cubism: scraps build up ("synthesize") the image, rather than take it apart. Juan Gris took to the geometric style with seeming ease, using a beautiful range of colors. Fernand Léger, another artist to

try cubism, specialized in industrial subjects reflecting the modern age.

The first exhibition of cubist works was in 1911, and other shows followed after World War I as the movement achieved a wider following in Europe and the United States. Cubism asserted the importance of the artist's viewpoint, and had a profound influence on both painting and sculpture. This was remarkable for a movement about which Picasso once said: "When we invented cubism we had no intention of inventing cubism. We wanted simply to express what was in us."

Key artists:
Alexander Archipenko (1887–1964), Georges Braque (1882–1963), Juan Gris (1887–1927), Fernand Léger (1881–1955), Pablo Picasso (1881–1973).

The City by **Fernand Léger** *1919. Oil on canvas. 91 x 177½ in (231 x 451 cm). Louise and Walter Arensberg Collection, Philadelphia Museum of Art, PA.*

DADA

From modest beginnings, dada became one of the most important modern movements of the 20th century. Controversial and provocative, dadaism challenged all conventional ideas about art.

The movement began in 1916 when a group of artists and writers from several countries gathered in neutral Switzerland to escape from the war raging in the surrounding countries. At first they wrote antiwar poems, sang satirical songs, and exhibited the latest international modern art by cubist, expressionist, and futurist artists in their little cabaret, which they called the Cabaret Voltaire. Soon, they became more experimental. Wearing a cylindrical blue cardboard costume, Hugo Ball, a German writer, performed "sound-poems," consisting of nonsensical words. Dancers performed "abstract" dances wearing masks made from scrap paper and string. Tristan Tzara, Richard Huelsenbeck, and others performed "simultaneous poems." For these, they would recite nonsensical verse in different languages, whistle, shout, bang kettles, jangle bells, and make other random noises. Soon they adopted the word "dada" (French for hobbyhorse) as a name for their activities, and published a magazine. All of this had little to do with art in the traditional sense; indeed, much of the spirit of dada was a protest against art and contemporary society.

The dadaists regarded the middle-class as fools. They were disgusted by World War I and the patriotic ideas that had caused it. They also regarded most art and literature as redundant, outmoded, and false. For many dadaists "chance" was a more legitimate way of working than merely making illusions.

For example, Jean Arp made "collages according to the laws of chance" by simply dropping scraps of paper onto a page on the floor and fixing them as they landed. Tzara made poems by cutting words out of newspapers, mixing them in a bag and then drawing them out one by one. In 1917 they set up a "Dada Gallery" to promote fresh new art. But they were most famous for their "soirées," performances in which they often used humor and insult to shock.

Dada became an international movement. Richard Huelsenbeck left Zurich in 1917 and went back to the German capital, Berlin. There, another dada group formed. Berlin was a city in chaos, people were poor, the streets were filled with wounded soldiers, and revolution was brewing. In this atmosphere dada took on a political, and sometimes aggressive, character. John Heartfield pasted together scraps of photographs and fragments of text from magazines and advertisements to produce new images that often poked fun at politicians or celebrated the new fashions and technologies. He called these images "photomontages." Later, in the 1930s, Heartfield effectively used the technique to make anti-Nazi posters and magazine spreads. The dadaists also produced little magazines in which photographs, snippets of text, and George Grosz's satirical drawings were mixed together under cheeky headlines, such as "Invest your money in Dada!"

In 1920, a huge "International Dada Fair" was held in Berlin. In an attempt to distance themselves from the art market, the dadaists insisted that their works were merely "products," and that they were not artists but technicians who "assembled" the objects. A stuffed soldier's uniform hung from the ceiling and large posters were put up on the walls with slogans such as "Take Dada seriously!" The "products" that they exhibited included photomontages and assemblages—combinations of objects such as light bulbs, tailors' dummies, cutlery, false teeth, and newspapers.

In 1919 a group formed in Cologne around Arp (one of the original dadaists) and his friend Max Ernst. They made collages together, and scandalized the public with outrageous exhibitions, one of which was closed down by the police. In the German city of Hanover a single artist, Kurt Schwitters, formed his own version of dada, called "Merz." Schwitters collected debris he found in the streets and parks of his city, and this became the material for his Merz pictures. He also wrote and performed many poems.

Dada found its way to Paris and New York, too. In Paris, the dadaists were more concerned with literature than art. Initially grouped around Tristan

Door, 11 Rue Larrey by Marcel Duchamp
1927. Wooden door made to artist's design. 86½ x 24¾ in (220 x 63 cm). Galerie Schmela, Dusseldorf.

Tzara, dadaism was soon rejected in favour of surrealism. By 1920, dadaism had shaken up the art world. Many of the ideas that developed into minimalism, pop art, and conceptual art in the 1960s can be traced to the challenges dada laid down more than 40 years earlier.

Key artists:
Jean (or Hans) Arp (1887–1966), Marcel Duchamp (1887–1968), Max Ernst (1891–1976), George Grosz (1893–1959), Raoul Hausmann (1886–1971), Kurt Schwitters (1887–1948), Tristan Tzara (1896–1963).

Torso with Raised Arms by Jean Arp
1928. Painted wooden relief. 15 x 13 x 2¼ in (38 x 33 x 6 cm). Private collection.

EXPRESSIONISM

The expressionist movement grew up in the early 1900s. Its influence could be found throughout northern Europe, in theater, movies, poetry, even cabaret, but it is most strongly linked with the visual arts in Germany. At the time, artists were not interested in creating a new identity; they were much more ambitious. In the words of the poet Johannes R. Becher, "Poets, painters, and musicians [were] all working together to create 'the art of the century'." These people had the revolutionary spirit of youth, and a cause to rebel against. Society was changing—cities were expanding and industry was triumphant, but the increasingly urban way of life created an underlying anxiety and alienation.

So, in 1900, Ernst Ludwig Kirchner, a student of architecture, "had the bold idea of renewing German art." Five years later he formed—with three fellow-students—the group known as Die Brücke, or The Bridge, which lasted until 1913, and became one of the mainsprings of the expressionist movement. The members of the group felt a strong affinity with the emotionally charged paintings of Vincent Van Gogh. They were uninhibited in using harsh, distorted, or exaggerated lines, and expressed the brilliance of nature and their own intense responses with vivid coloring that demanded an emotional reaction from the viewer. These are the hallmarks of expressionism.

An older artist, Emil Nolde, who also joined Die Brücke for a short time, was a key figure in the expressionist movement. He revealed his ecstatic, religious nature in his landscapes, which have been described as "tempests of color." He applied paint thickly, with brush, scraps of card, or even his fingers. He went on to paint portraits and religious pictures.

Complementing Die Brücke was another group of artists, based in Munich, who looked for ways to express their more spiritual, inner life. They called themselves Der Blaue Reiter, or The Blue Rider. For these artists, who included Wassily Kandinsky, Franz Marc, and August Macke, color was crucial for emotional, and also symbolic reasons. The Blue Rider group lasted for only three years, but the works that

Sailboats by **August Macke** *c1911. Oil on canvas. Dimensions unavailable. Private collection.*

emerged in this time proved some of the most important of modern art. Kandinsky produced the first abstract paintings at this time, for example.

These avant-garde artists found an energetic promoter in Herwarth Walden, who published a magazine and opened a gallery in Berlin, which were both named *Der Sturm* (The Storm). Walden was the first to publicize expressionism as a movement. From 1912 his shows brought together the work of progressive artists from other centers in Europe, some of whom are now firmly connected with the movement. These included the Belgian painter James Ensor, and the Viennese

Self-Portrait by **Oskar Kokoschka** *1913. Oil in canvas. 32 1/4 x 19 1/2 in (82 x 49.5 cm). Museum of Modern Art, New York, NY.*

FAUVISM

artist Oskar Kokoschka. The latter specialized in portraits that exposed the inner reality of his sitter. Sometimes he used a heavy impasto from which his figures emerge, rather than being defined by outline; sometimes he scraped paint from the canvas, leaving just stains of color to indicate his sitter's state of being.

Egon Schiele was another Viennese painter attracted to Berlin, which he described as "hell-hole and paradise in one." He believed "there is no 'new art'. But, there are new artists…." He transmitted his own sense of menace to his figure drawings and watercolors, producing harsh, elongated human forms of erotic power. Expressionist art shocked the establishment: Schiele was arrested in 1912 for producing what were considered pornographic pictures, and the following year expressionist work in general was attacked as "endangering German youth."

Expressionism effectively ended in 1914, with the outbreak in Europe of World War I, yet its influence lived on. After the end of the war the artist George Grosz, for example, used expressionist exaggeration to expose the rottenness of German society. In that expressionism allowed personal feelings to be expressed for their own sake, and gave new possibilities to color and line, it was perhaps one of the most liberating of art movements.

Key artists:
Wassily Kandinsky (1866–1944), Ernst Ludwig Kirchner (1880–1938), Oskar Kokoschka (1886–1980), August Macke (1887–1914), Franz Marc (1880–1916), Gabriele Münter (1877–1962). Emil Nolde (1867–1956), Egon Schiele (1890–1918).

In 1905 a handful of artists burst on the Paris scene with an exhibition of paintings remarkable for their brilliant, "unreal" color and lack of perspective. For this exuberant break with convention, one art critic declared, "A pot of paint has been flung in the face of the public." Another critic branded them "fauves," or wild beasts.

The fauvists included André Derain, Henri Matisse, Maurice de Vlaminck, Albert Marquet, and the Dutchman Kees Van Dongen. Matisse, aged 36 and the eldest of the group, was seen as its leader. While working in the brilliant light of the south of France in 1904, he had begun experimenting with color purely for emotional or visual effect (so shadows might be green, trees red, and a road yellow). In 1905 Derain joined Matisse, and made the similar discovery that "the new conception of light" meant eliminating shadow. Together they painted the colorful boats, the houses of the Mediterranean coast, and the sunlit landscape.

Like his fellow fauvist Vlaminck, Derain was highly impressed by the paintings of Vincent Van Gogh, who used color to express feeling, and of Paul Gauguin, who ignored perspective and the literal meaning of color. Dérain often used paint straight from

Restaurant of the Machine at Bougival by **Maurice de Vlaminck** *1905. Oil on canvas. 23¹/₂ x 32 in (60 x 81.5 cm). Musée d'Orsay, Paris.*

the tube, and short, vigorous brush-strokes. In this way he was able to paint fauvist pictures even in the more subdued surroundings of London, where he conjured up barges in red and blue on a green River Thames.

Despite the storm of criticism aroused by the fauvists' 1905 show, Raoul Dufy and Georges Braque were attracted to their group. Dufy's approach was to draw an outline in black and white, then fill in the blank space with a fairly narrow range of intense colors—blue, green, yellow. Braque, who was later to become famous for his monochrome cubist works, was also inspired by fauvism.

The fauvists drifted apart after their 1906 show, but left an important legacy by liberating color from its traditional descriptive role, and making their own feelings the starting point of a picture.

Key artists:
André Derain (1880–1954), Raoul Dufy (1877–1953), Albert Marquet (1875–1947), Henri Matisse (1869–1954), Kees Van Dongen (1877–1968), Maurice de Vlaminck (1876–1958).

FOLK ART

The term folk art refers to the objects, decorations, sculptures, and paintings made in a traditional manner by craftsmen and -women who did not receive any formal, academic training in the arts. Typical products of folk art include signs, baskets, ceramics, wood carvings, and embroideries—objects that are intended to be used on a daily basis but that are also produced to celebrate special occasions such as weddings and funerals.

Folk art is often described as "timeless": it tends to change very little over long periods of time, and continues to repeat the techniques and characteristics that have been handed down through the generations. Consequently, folk art is not usually subject to the vagaries of fashions or taste. It has a unique, childlike quality that is immensely attractive. It is only in the 20th century, however, that folk art has been recognized and celebrated by artists and critics—in short, people outside the communities in which it was produced. The first large-scale exhibition of folk art was held at the Museum of Modern Art in New York in 1938.

***St Ives* by Alfred Wallis** *1928. Oil on wood. 10¼ x 15½ (26 x 39 cm). Tate Gallery, London.*

Stylistically, folk artists have seldom made "true-to-life" copies of the world around them. Instead the pictures they create are non-naturalistic, in which simplified or exaggerated forms are used to communicate their feelings about what they see. Because none of these artists has received formal training, compositions are usually static and symmetrical, and forms are presented frontally. Overall, compositions are often decorative, as forms and patterns are repeated.

Some folk artists, such as Edward Hicks and Linton Park, were amateur artists who followed the latest developments in high art, and often borrowed motifs and figure arrangements from well-known paintings that had been reproduced in the form of popular prints.

Much folk art of the past, and some that continues to be practiced today, was and is a product of rural and largely pre- or nonindustrialized communities. In a rapidly urbanizing and industrializing Western world, the true folk artists, many of whom were anonymous, were replaced by painters working within modern, industrial societies and producing consciously "naïve" or "primitive" art. Henri Rousseau was one of the best known of these "Sunday painters," but he was later accepted as a professional.

Key artists:
Edward Hicks (1780–1849), Morris Hirschfield (1872–1946), John Kane (1860–1934), Grandma Moses (1860–1961), Linton Park (1826–1906), Joseph Picketts (1848–1918), Horace Pippin (1888–1947), Henri Rousseau (1844–1910), Alfred Wallis (1885–1942).

FUTURISM

Futurism was a flamboyant and consciously modern movement. It originated in Italy in 1909 when a controversial writer, Filippo Tommaso Marinetti, published a manifesto demanding a new art for a new age, and announcing the arrival of "futurism." He soon gathered around him a group of like-minded artists—painters, sculptors, architects, photographers, filmmakers, and musicians—who began to explore ways of making works that would express the "dynamism" of modern life.

Manifestos became a very important part of futurist activity. These made a series of demands for futurist revolution in all kinds of fields: from painting to fashion, photography to the role of women. Futurism was more than a style; it was an attempt to wrench Italy out of its glorious but weighty past, and into the new, technological age of aeroplanes, electricity, and bombs.

Full of fragmented, semi-abstract forms, and bright colors, futurism was expressed through paintings by Umberto Boccioni, Carlo Carrà, and Giacomo Balla. These artists attempted to convey the exciting, dynamic sensation of speeding cars, galloping horses, clattering typewriters, busy train stations, and violent public demonstrations.

One of futurism's most important principles was "simultaneity." This was an attempt to compress a range of sensations, appearances, and experiences over time into one image or written passage. Boccioni, for example, painted a triptych—a painting in three parts—called *States of Mind* (1911), to convey the experience of a train leaving a station. One panel showed passengers whisked away by the train;

GOTHIC

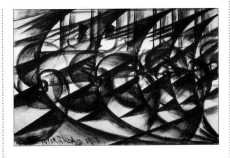

***Abstract Rapidity* by Giacomo Balla**
*1913. Oil on canvas. 19¾ x 30¾ in
(50 x 78 cm). Private collection.*

another showed the train itself in a whirl of steam; the third showed the people left behind at the station.

In keeping with their fascination with machines, their desire for violent change, and their showy aggressiveness, the futurists welcomed the idea of war. In 1912 Marinetti developed a new combination of art and poetry with his "words-in-freedom," in which words, punctuation, and drawn marks were scattered in all directions across the page to evoke whirring propellers, gunfire, and bombs. When World War I broke out, the futurists called for Italy to take part in the fighting. Many futurists became soldiers, and Boccioni was among those killed.

After the war, only a very diluted version of futurism survived, but many of the movement's ideas and techniques were taken up and developed by the dadaists, the constructivists, and by some later expressionists.

Key artists:
Giacomo Balla (1871–1958), Umberto Boccioni (1882–1916), Carlo Carrà (1881–1966), Filippo Tommaso Marinetti (1876–1944), Luigi Russolo (1885–1947), Gino Severini (1883–1966).

Gothic was the style of architecture, painting, and sculpture that prevailed mainly in northern Europe from the mid-12th century until the 16th century. It was primarily a French style, but its ideas spread—with regional variations—to England, Spain, Germany, and parts of Italy. It is best identified as an integrated fusion of architecture, sculpture, painting, and stained glass, and can be seen in the great cathedrals of Chartres, Reims, Amiens, or Sainte Chapelle, Paris.

Gothic is most clearly recognizable in terms of its architectural features. Gothic architecture appears light and graceful. Its churches soar to great heights, with tall, pointed spires and high, vaulted naves resting on slender columns. Its specific characteristics are pointed arches, flying buttresses (projecting arches of masonry built on the outside of a wall to give structural support to the interior), and elaborate tracery (ornamental stonework within a window): these building devices made possible the construction of churches of such heights.

Walls were no longer a solid mass of stone, but stone scaffolding that opened out into huge windows; large areas of stained glass replaced mural decoration. An outstanding example is the Sainte Chapelle in Paris, where light pours in through brightly colored glass. Stained glass of a technically high quality was widely used during the Gothic period.

Much Gothic sculpture is integral to the architecture, appearing mostly on the exterior around doorways, portals, capitals, and tympanums. In general terms, Gothic sculpture is distinguished by its vertical, static quality, with elongated figures and rigid postures, and variable attempts at naturalization. The

Notre-Dame Cathedral, Chartres (south side) *The main part of the cathedral was built in 30 years in the mid-13th century, and shows many pure Gothic features.*

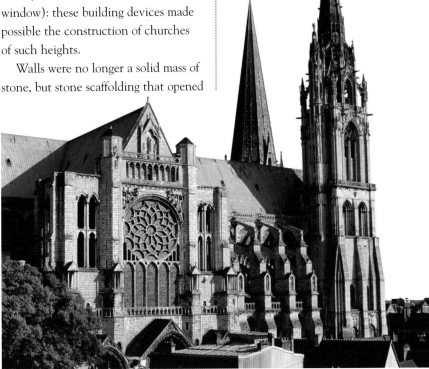

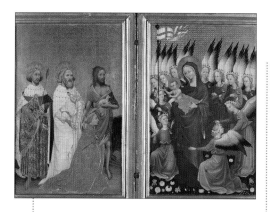

The Wilton Diptych (front) *after 1394.*
Oil on panel. 18 x 11 1/2 (46 x 29 cm).
National Gallery, London.

figures of saints at Chartres Cathedral, for example, are each given their own individuality, and there is an indication of form beneath the drapery. Large-scale sculptural programmes such as this were popular, particularly in France. Elsewhere, departures from this tradition began to occur, particularly in Italy, where the sculptor Nicola Pisano imparted a new realism into pulpit sculpture using crowded figure scenes full of movement and expression.

Manuscript illumination was also a productive source of work during the Gothic period, and was used in devotional books such as bibles, psalters (prayer books), and for collections of poetry and songs. An art form centered around the courts of noblemen, these illuminations are characterized by elegant figures, small, intimate details (with motifs taken from the plant and animal kingdoms), and by rich use of color and gold. Some of the finest examples are those by the Limbourg Brothers, created for the Duke of Berry in Burgundy. Tapestry, too, was popular with noblemen, to decorate the bare walls of large rooms. These were similarly richly ornamented with flora and fauna, and often depicted tales of chivalry, legends, and hunting scenes.

The painting of the Gothic period is not easy to define on stylistic grounds. Broadly speaking it is two-dimensional in approach: figures are slender, serene, and graceful; faces are stylized and based on idealized prototypes. Simple, stylized architectural backgrounds were used, and there was minimal concern to depict accurate perspective.

The influence of French Gothic art gradually spread to other parts of Europe. Although Italy was somewhat resistant to the style, the greatest abundance of paintings from this period actually come from Italy.

The artist who best adopted Gothic characteristics was Simone Martini. He influenced the development of the style into "international Gothic," a refined blend of north European and Italian elements characterized by aristocratic elegance and rich naturalistic detail. International Gothic spread throughout Western Europe in the late 14th and early 15th centuries.

Key sites:

Chartres Cathedral (France), Amiens Cathedral (France), Reims Cathedral (France), Notre-Dame, Paris (France).

Key artists:

Gothic: Tino da Camaino (c1285–1337), Arnolfo da Cambio (d. c1302), Duccio di Buoninsegna (c1255–c1319), Taddeo Gaddi (c1300–1366), Giotto di Bondone (1266/67–c1337), Ambrogio and Pietro Lorenzetti (active 1320–48), Simone Martini (c1284–1344), Nicola Pisano (c1220/5–1278/84).
International Gothic: Gentile da Fabriano (c1370–1427) Limbourg Brothers (Paul, Herman, and Jean) (all d.1416), Pisanello (c1395–1455/56), Stefano Sassetta (c1400–50).

HARLEM RENAISSANCE

The Harlem Renaissance began in the Harlem neighborhood of New York City in the 1920s, and marked the 20th century's first period of intense activity by African Americans in the fields of music, literature, and the visual arts. The artists of the Harlem Renaissance came from a variety of different backgrounds, but were united in their desire to portray the black American experience. The philosophy of the movement combined realism, a consciousness about the artists' ethnic origins, and Americanism.

In their attempts to move away from the sentimental and stereotypical portrayals of people of African descent by established white artists such as Thomas Eakins, Robert Henri, and the painters of the Ashcan school, black artists tried to depict themselves and their lives in the United States. Although it was a shortlived movement (it ended at the time of the Stock Market Crash in October 1929), the Harlem Renaissance encouraged black artists to emerge for the first time as an identifiable force and a vital part of American culture.

The leading visual artists during the Harlem Renaissance were the muralist Aaron Douglas, whose iconography was derived from rituals in African dance; the sculptor Meta Warrick Fuller—the first black American artist to draw on African folktales for her subject matter; Palmer Hayden, who produced realistic depictions of black historical events; and William H. Johnson, who worked through styles of painting that ranged from impressionism and realism to an expressionism that bordered on primitivism.

Harlem's artistic activity stimulated similar activity in other cities, and the

HUDSON RIVER SCHOOL

spread of Renaissance ideals was further aided by the Harmon Foundation, a philanthropic organization founded in 1928 that organized several traveling exhibitions. Among the artists whose work featured in these touring shows were Hale Woodruff, the creator of murals on black history; Sergent Johnson, who was principally a sculptor but also a talented graphic artist, painter, and ceramist; the sculptor William E. Artis; and Lois Mailou Jones, one of the strongest forces in teaching and promoting African-American art.

Key artists:
William E. Artis (1919–77), Aaron Douglas (1899–1979), Meta Warrick Fuller (1877–1968), Palmer Hayden (1890–1973), Sergent Johnson (1887–1967), William H. Johnson (1901–70), Lois Mailou Jones (1905–), Hale Woodruff (1900–80).

***The Ascent of Ethiopia* by Lois Mailou Jones** *1932. Oil on canvas. 23 1/2 x 17 1/4 in (60 x 44 cm). Milwaukee Art Museum, Milwaukee, WI.*

The Hudson River school is the name given to the first group of American landscape painters of the 19th century. Part of the Romantic movement, the Hudson River school was never a formal group, but more a loose association of artists who wanted to paint the unspoiled wilderness of a country that was still largely unexplored. The school was founded on the spiritual ideals of Thomas Cole, who believed that God was in nature, and wanted to stress the importance of man's union with nature. With artists such as Asher B. Durand, Cole traveled from his home in New York City along the Hudson River and through the Catskill Mountains to sketch the landscape. While Cole painted the monumental four-canvas series *The Voyage of Life* (1842), Durand produced more intimate nature studies.

Although Cole had many followers, he had only one student, Frederic E. Church. Church became as passionate as Cole in his love for nature, but he was inspired to seek out wider horizons than his tutor: he traveled extensively in the Middle East, in Labrador, and in North and South America. Following two trips to Ecuador, Church completed the meticulously detailed *The Heart of the Andes* (1859).

Like Church, many of Cole's followers depicted scenery beyond the Hudson River Valley, painting nature in different seasons and weather conditions. Martin Johnson Heade captured the drama of the weather in

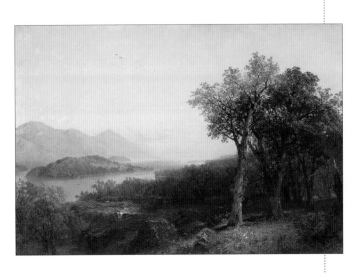

***Autumn Afternoon on Lake George* by John Kensett** *1864. Oil on canvas. 48 3/4 x 72 1/2 in (124 x 184 cm). Corcoran Gallery of Art, Washington, D.C.*

Approaching Storm: Beach Near Newport (c1860). Albert Bierstadt painted large-scale pictures depicting the grandeur of the far West in paintings such as *Rocky Mountains—Lander's Peak* (1863).

A number of the Hudson River artists, including George Inness and Alexander Wyant, responded to new ideas from France. In particular, they were influenced by the Barbizon painters, with their expressive brushwork and varied subject matter, including still lifes and interior scenes. Inness would later become associated with impressionism in the United States, largely for his loosely brushed, atmospheric style.

Key artists:
Albert Bierstadt (1830–1902), Frederic E. Church (1826–1900), Thomas Cole (1801–48), Asher B. Durand (1796–1886), Martin Johnson Heade (1819–1904), George Inness (1825–94), John Kensett (1816–72), Alexander Wyant (1836–92).

IMPRESSIONISM

The impressionist movement was one of the greatest landmarks in European art. It originated in France in the 1860s, but its impact was felt throughout the West, and it helped to shape the course of modern art. It was not a unified movement with a precise set of artistic aims, but it provided a means for a group of like-minded, avant-garde artists to exhibit their work together and exchange ideas.

The nucleus of the group included Pierre-Auguste Renoir, Claude Monet, Alfred Sisley, Paul Cézanne, Edgar Degas, Camille Pissarro, and Edouard Manet. Sharing a common dislike for the conventional exhibitions at the Paris Salon, they decided to stage their own show as an "anonymous society." The exhibition opened in April 1874, and was lambasted by the critics, who reserved their most scathing comments for Monet's *Impression: Sunrise* (1872). The title stuck, and soon the entire group were dubbed "impressionists."

One of the principal sources of impressionism lay in the realist movement, which Gustave Courbet and his followers had pioneered in the 1840s. The realists had campaigned against academic art, believing that it focused too heavily on the past and on intangible ideals. Manet now declared that: "One must be of one's time and paint what one sees." Charles Baudelaire, a respected poet and critic, also urged painters to celebrate "the heroism of modern life."

Paris had been substantially rebuilt by Baron Georges-Eugène Haussmann in the 1850s and 1860s, becoming the most elegant and modern metropolis in Europe. As such, it proved an ideal focus for the forward-looking

***Impression: Sunrise* by Claude Monet**
1872. Oil on canvas. 19 x 24¾ in (48 x 63 cm). Musée Marmottan, Paris.

impressionists. They chose as their subject matter Parisians enjoying themselves in dance-halls, cafés, and bars, or on weekend jaunts away from the center—boating on the River Seine or going to the races. They depicted the most fashionable entertainments, whether the ballet, the theater, or the circus; they even portrayed recent technological developments, such as the railroads. Some impressionist pictures touched on the seamier side of city life, raising eyebrows among a public more accustomed to uplifting scenes from history or mythology.

The ambition to "paint what one sees" had even greater implications for impressionist landscape artists. Before the impressionists, it had been standard practice to compose landscapes in a studio. Even the more progressive groups, such as the Barbizon school, who painted studies in the open air, still tended to create their finished works indoors. To the impressionists this seemed absurd: if artists wished to capture nature truthfully, they had to be directly in front of it when they were painting. This tendency, known as painting *en plein air* ("in the open air"), was one of the fundamental tenets of impressionism.

There was, of course, one obvious drawback to painting *en plein air*—the light and the atmospheric conditions kept changing. To counter this, the impressionists worked quickly, often employing cursory brushstrokes and a highly inventive approach to color. Instead of painting firm outlines and grey or black shadows, they adapted the optical law of complementary colors, which showed that each color tinted neighboring objects with its complementary shade. Working forward

from this, they were able to produce combinations of color that fused in the spectator's eye, rather than on the artist's palette. This fusion would only take place if the painting was viewed from a suitable distance. If seen from too close, it could resemble a formless mess of colors. Again, this disturbed spectators who were used to seeing a high degree of finish on artworks. To them impressionist paintings seemed like sketches or studies.

The development of impressionism was also affected by two other visual stimuli: photography and Japanese prints. The invention of photography had caused consternation in the art world, with some people predicting that it would bring an end to painting. In fact, it prompted some artists to re-examine the basics of composition.

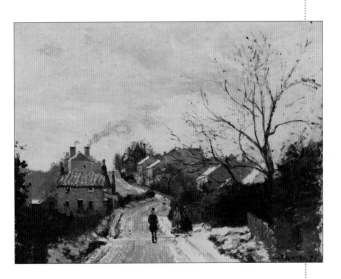

Fox Hill, Upper Norwood by **Camille Pissarro** *1870. Oil on canvas. 14 x 18 in (35.5 x 45.5 cm). National Gallery, London.*

Several impressionists—particularly Degas and Manet—tried to mimic the spontaneity of a snapshot, by cutting figures off at the frame, or showing them reacting to unseen events occurring outside the picture space. Others, such as Pissarro and Monet, drew inspiration from the blurred images found on early photographs.

Japanese prints, which began to appear in the West in the 1850s, also had a profound influence, particularly on Mary Cassatt and Degas. With their use of bold, flat colors, their emphasis on decoration rather than detail, and their disregard for the laws of perspective, they undermined many of the artistic precepts that had been followed since the Renaissance.

Key artists:
Gustave Caillebotte (1848–94), Mary Cassatt (1844–1926), Edgar Degas (1834–1917), Edouard Manet (1832–83), Claude Monet (1840–1926), Berthe Morisot (1841–95), Camille Pissarro (1830–1903), Pierre-Auguste Renoir (1841–1919), Alfred Sisley (1839–99).

The Star by **Edgar Degas** *c1878. Pastel on paper. 15 x 11 in (38 x 28 cm). The Philadelphia Museum of Art, PA.*

MANNERISM

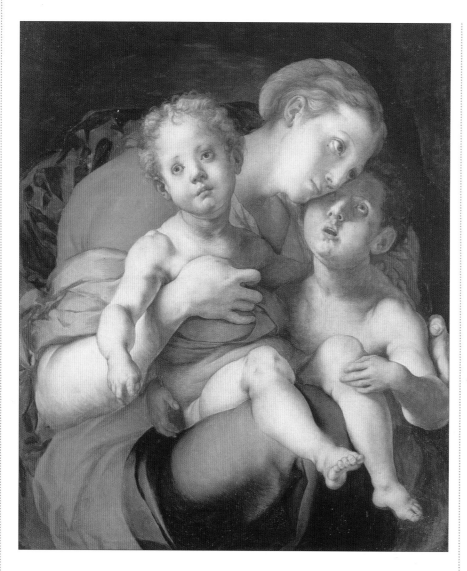

Madonna and Child with the Young Saint John by Pontormo *c1515–19. Oil on panel. 35 x 29 in (90 x 74 cm). Galleria degli Uffizi, Florence.*

Mannerism flourished from about 1515 to 1590. It was centered in Italy, but spread to other countries too. Some art historians see it as the last phase of the Renaissance, others as an independent period with its own aims and artistic standards, separating the Renaissance from the baroque.

There were two main factors behind the emergence of mannerism. The first was that during the 16th century the rise of Protestantism had led to a decline in power of the Catholic Church, which had once unified Europe. To many people the world

seemed increasingly violent, complex, and unstable. The mannerist style was able to express this mood of anxiety, loss, and uncertainty.

In addition, many young artists felt by this time that the Renaissance style had reached technical perfection through the mastery of composition, perspective, anatomy, and color. As a result, they felt the need to experiment

with new styles. Mannerism deliberately distorted all those features that gave Renaissance art its distinctive clarity, harmony, and balance. The new, exaggerated style was intended to have a more complex and disturbing emotional impact. However, although it appeared to reject many of the values and achievements of the Renaissance, mannerism actually developed directly from it, and was inspired in particular by the later works of Raphael and Michelangelo Buonarroti. Both artists, through their use of powerfully built figures in tense, complex poses, had brought a sense of drama to painting.

In mannerist paintings the figures are, typically, impossibly tall and thin, and stand in awkward, twisted poses. Colors are harsh and unnatural, scale and perspective greatly distorted, and the light artificial. The works usually have a disturbing, dreamlike quality.

In time, mannerist paintings began to acquire a greater refinement and sophistication, although they usually retained an air of strangeness and unreality. This refinement is particularly true of portraits, which often depict elegant aristocrats who, cold and remote, seem to live in a world of their own. Mannerist sculptors created long, sinuous figures that are either frozen in a moment of high drama, or posed with a sensuous and languid elegance.

Key painters:
Agnolo Bronzino (1503–72), Giulio Romano (c1499–1546), El Greco (1541–1614), Pontormo (1494–1556), Tintoretto (1518–1594).
Key sculptors:
Benvenuto Cellini (1500–71) and Giambologna (1529–1608).

MINIMALISM

Minimalism evolved in the United States in the 1960s, when several young artists began to explore ways of reducing art to its barest essentials. They were keen to move away from the style of abstract expressionism then dominating American art. They wanted to take the individual gestures of "expression" out of art, leaving behind only a pure, rational form.

Crucial to the philosophy of minimalism was that the work should originate in the artist's mind. The forms that the artworks took therefore often appear stark and, indeed, look very little like "art" in the traditional sense. In minimalism we find few paintings or carved or cast sculptures. No subject is represented visually. Minimalist works are usually three-dimensional, although Frank Stella produced works on canvas consisting of repeated, regular, geometric outlines on dark backgrounds. Minimalist works sometimes involve complex construction processes, but the "look" of the objects is mass-produced, banal, and shows little sign of traditional artistic skill or handicraft. They most often consist of industrial objects and materials, such as neon lighting tubes, bricks, or sheets of metal. These materials were not "made" by the artists; rather they stood for a reduced, purified idea of an artwork.

Minimalism radically challenged what the public expected of art. Many people were outraged, for example, when in 1972 the Tate Gallery in London bought *Equivalents VIII* (1966) by Carl Andre, which consisted of groups of housebricks. It was clear that "art" had now moved far away from traditional values, such as the "skill" of the artist in making the object.

Minimalism is related to pop art in that both movements made use of objects and materials from the everyday world, but minimalism involved stricter, more intellectual processes. The importance that minimalist artists attached to the "idea" of the work, rather than the making of it, became an important principle for conceptual art.

Key artists:
Carl Andre (1935–), Dan Flavin (1933–), Donald Judd (1928–), Sol LeWitt (1928–), Robert Morris (1931–), Richard Serra (1939–), Frank Stella (1936–).

Bonne Bay I **by Frank Stella** *1969. Oil on canvas. 32 x 63¾ in (81 x 162 cm). Leo Castelli Gallery, New York, NY.*

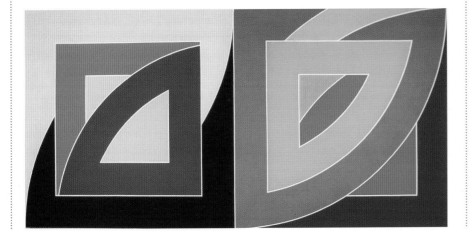

NEOCLASSICISM

Neoclassicism, or "new classicism," was an esthetic style that began about 1750 and lasted until about 1830, although its influence has continued through the 20th century, particularly in architecture. Neo-classicism first began in France and Italy, spreading throughout Europe to Russia, Britain, and beyond, to the United States and to Australia.

Neoclassicism was a reaction against the rococo style, which it dismissed as "frivolous." Instead, the neoclassicists were interested in the antique: the style is characterized by a strong classical influence. This interest was encouraged by the discovery by archaeologists of ancient cities such as Pompeii, Herculaneum, and Paestum in southern Italy, which were uncovered between 1738 and 1756.

Subject matter for the neoclassicists was often determined by classical history and mythology, but it was also possible to depict contemporary events in the style. This was because neoclassicism held strong moral and ethical implications.

In France the neoclassical style was associated with the desire on the part of the emperor Napoleon Bonaparte to restore ancient "virtues," such as heroism, to contemporary civic life. This aspect of neoclassicism was expressed by Jacques-Louis David in works such as *The Oath of the Horatii* (1785)—a type of painting known as a "history painting."

In the United States interest in neoclassicism was stimulated by American sympathy for the Greeks, who from 1821 to 1832 were engaged in a battle for independence from the Turks. Neoclassicism became identified by many Americans with the ideals of

OP ART

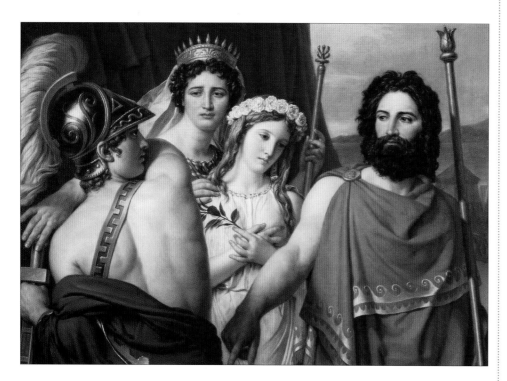

The Anger of Achilles by Jacques-Louis David *1819. Oil on canvas. 41½ x 57 in (105 x 145 cm). Kimbell Art Museum, Fort Worth, TX.*

democracy, and consequently it became expressive of American social and political ideals.

While history painting formed a major part of the output of many artists, other genres, such as landscape painting, were also influenced by neo-classicism, and artists such as J. M. W. Turner incorporated ancient buildings, both real and imagined, into idealized classical landscapes such as *Dido Building Carthage* (1815).

Neoclassicism was not confined to the fine arts of painting and sculpture. The use of classical motifs, subjects, and decorations became popular in the decorative arts: the British ceramics manufacturer Josiah Wedgwood helped popularize the style in china wares for everyday use, as well as making a copy of the ancient Roman Portland Vase.

In architecture, neoclassicism was characterized by the use of the classical orders—Doric, Ionic, and Corinthian— for columns and pilasters, and by the

use of pediments, friezes, and classical ornamental motifs. This can be seen, for example, in James Hoban's design for the White House (1793–1801), in Washington, D.C.

Key artists:
Antonio Canova (1757–1822), Jacques-Louis David (1748–1825), Gavin Hamilton (1723–98), Jean Auguste Dominique Ingres (1780– 1867), Angelica Kauffmann (1741– 1807), Anton Raphael Mengs (1728– 79), J. M. W. Turner (1775–1851), Benjamin West (1738–1820).

Key architects:
Robert Adam (1728–92), James Hoban (1756–1821), Benjamin Latrobe (1764–1820), Charles-Nicholas Ledoux (1736–1806).

Op art, an abbreviation of "optical art," is the name given to the style of abstract art that became popular in the 1960s. Op art seeks to give the illusion of movement by exploiting optical effects.

Devices that created an after-image, or that produced the effects of "dazzle" and vibration, had been used by some artists in the past, but only as a feature of their work. In trompe-l'oeil, for example, our imagination is stimulated to the extent that we believe we are seeing in three dimensions rather than two. The op artists made these devices the central or sole objects of their art, and so their art is totally abstract.

Op art may take various forms: in addition to paintings there are works in slight relief, and constructions that depend for effect on the light cast on them and/or movement of the object and the spectator. Op art therefore often overlaps with "kinetic art."

The characteristics of op art are simplicity, geometric forms, and mechanical patterns, which are often varied in density to produce an implied movement into space—the surface of some op paintings appear to swell and project out from the surface of the canvas. There is usually a meticulous, hard-edged application of paint that has eliminated all traces of brushstrokes.

While some op artists abandoned color in favor of black, white, and gray tones, others explored the potentials of color contrasts, optical mixing, and the Purkinje effect. This is the gradual change of color caused by changes in the length of light waves. We notice this most at dusk: as we lose the longer wavelengths of light (red, orange, and yellow), cool colors such as the greens of trees and grass appear more intense.

POP ART

When daylight begins again, and long, warm wavelengths predominate, objects seem to take on a golden glow.

The most famous practitioners of op art are Victor Vasarely and Bridget Riley. Vasarely began painting black-and-white "eye stimuli" in 1935. These included checkerboard compositions with chess pieces, and paintings of zebras and tigers. Vasarely believed it was more important for the spectator to experience the presence of a work of art than to understand it.

Riley's interest in optical effects was inspired by the postimpressionists' painting technique of pointillism, in which colors are not mixed on the palette but laid separately on the canvas and "optically mixed" by the spectator. Riley demonstrates her mastery of the effects of op by varying the size, shape, or placement of repeated forms arranged in an overall pattern.

Key artists:

Yaacov Agam (1928–), Richard Anuszkiewicz (1930–), Carlos Cruz-Diez (1923–), Bridget Riley (1931–), Victor Vasarely (1908–97).

Fall **by Bridget Riley** *1963. Emulsion on hardboard. 55 1/2 x 55 in (141 x 140 cm). Tate Gallery, London.*

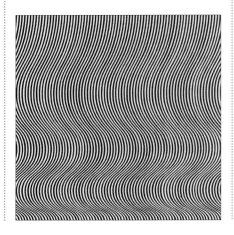

The first use of the term pop art is credited to the art critic Lawrence Alloway. He used it to describe the popular culture of advertising, posters, packaging design, magazines, television, and the movies that, unlike fine art, could be shared by all people regardless of class and artistic skill.

The term began to be applied to a wide variety of works created by professional artists, who used popular culture and the mass media for the sources of their images and, in some cases, their techniques. While some pop art works appeared to celebrate consumer products and celebrities, others took a more critical approach to the notion of mass consumerism.

The first pop art work was probably the British artist Richard Hamilton's collage, *Just What Is It That Makes Today's Home So Different, So Appealing*, made for a 1956 exhibition called "This is Tomorrow." Pop art made a bigger impression on the public after the 1961 Young Contemporaries Exhibition, which included works by David Hockney and R. B. Kitaj.

In the United States, similar ideas were being explored. Jasper Johns's paintings of flags and targets and his sculptures of beer cans, and Robert Rauschenberg's collages and "combine" pictures, featuring Coke bottles and magazine photographs, opened up a whole new range of subject matter.

Some critics asserted that the pop artists were simply copying the works of commercial artists; some pop art paintings do indeed look like straight copies. Roy Lichtenstein not only used comic book illustrations for his subject matter, but he also incorporated Ben Day dots (named after the man who invented the halftone printing process)

Varoom! **by Roy Lichtenstein** *1965. Magna on canvas. 56 x 56 in (142 x 142 cm). Private collection.*

into his works, making them appear as if they were printed rather than handpainted. Other observers saw pop art as a continuation of dada, because it embraced the use, or reproduction of, everyday objects, as Marcel Duchamp had done in his "readymades." The pop sculptor Claes Oldenberg used kapok stuffing and vinyl to create giant soft sculptures of everyday objects such as hamburgers. Andy Warhol took familiar objects—a Coke bottle, a soup can—or a familiar person such as Marilyn Monroe, and used the mass production technique of silk-screen printing to produce repeated images. Works in series now replaced the single "original" work of art.

Key artists:

Peter Blake (1932–), Derek Boshier (1937–), Richard Hamilton (1922–), David Hockney (1937–), Robert Indiana (1928–), Jasper Johns (1930–), Allen Jones (1937–), R. B. Kitaj (1932–), Roy Lichtenstein (1923–97), Claes Oldenberg (1929–), Eduardo Paolozzi (1924–), Robert Rauschenberg (1925–), Andy Warhol (1928–87).

POSTIMPRESSIONISM

Mont Sainte-Victoire by Paul Cézanne
1885–57. Oil on canvas. 23¾ x 32 in (65.5 x 82 cm). Metropolitan Museum of Art, New York, NY.

Van Gogh also used color for expressive and symbolic purposes, but in a highly personal and uninhibited manner. He painted quite ordinary subjects, such as his bedroom, a vase of flowers, or a landscape, transforming the scene into one of violent intensity using vivid colors, thickly applied paint, and rapid, frenetic brushstrokes.

Fry's 1912 postimpressionist show included works by Pablo Picasso and Georges Braque, who went on to develop other movements in modern art, such as cubism and abstract art.

Key artists:
Paul Cézanne (1839–1906), Paul Gauguin (1848–1903), Vincent Van Gogh (1853–90), Georges Seurat (1859–91), Paul Signac (1863–1935).

Postimpressionism was the name given to the art that followed impressionism. The word has come to loosely define any number of reactions against impressionism between about 1880 and 1905, such as symbolism, fauvism, neoimpressionism, and even the beginnings of expressionism. It was named by the critic Roger Fry, who organized an exhibition entitled, "Manet and the Postimpressionists," in London in 1910–11. The work of three artists, Paul Cézanne, Paul Gauguin, and Vincent Van Gogh, dominated the exhibition, although Georges Seurat and Paul Signac were also represented.

These artists rejected the naturalistic aims of impressionism, and sought instead to convey the essence of their subject through simplification of form. However, all pursued quite separate paths. Seurat concentrated on the scientific analysis of color known as neoimpressionism. Cézanne was concerned with the structural analysis of nature rather than with fleeting moments. He repeatedly returned to the same subject or site, such as Mont Sainte-Victoire, where he analyzed tiny variations in color and tone. He took a long time over his paintings, applying layers of tone with short, square brushstrokes.

Gauguin rejected naturalism in favor of subjects fueled by the imagination. He was interested in religious and symbolic themes, and drew inspiration from primitive cultures and non-European art, such as Japanese prints, Egyptian art, and Polynesian sculpture. He wanted his art to express strong emotions, which he achieved by using bold, often unrealistic colors.

Sunflowers by Vincent Van Gogh 1888. Oil on canvas. 36¼ x 28¾ in (92 x 73 cm). National Gallery, London.

POSTMODERNISM/KITSCH

Postmodernism is the late 20th-century movement in art, design, and architecture that rejects the ideals of the modern movement. Modernism, an esthetic ideology dominating artistic practice in the West for nearly 100 years, is exemplified by the teachings and products of the Bauhaus school of architecture and applied arts in Germany, and by the architecture of Le Corbusier and Ludwig Mies Van der Rohe.

The central beliefs of modernism were that, since the modern machine age had been born, new art forms that needed to be developed that were appropriate to the age. Their style was based on the principles of "form follows function." Modernists rejected remnants of the past such as decoration, ornament, and applied color, preferring geometric, abstract forms over organic, naturalistic ones. They also praised the values of purity, rationality, order, and simplicity. With these "universal" ideals, modernists attempted to create an international style.

In the 1960s, however, many artists and designers became disillusioned with modernism: it was seen as too elitist and serious. Postmodernists favored a more populist—and popular—approach, and set about reversing many of the modernists' "rules." Postmodernism is therefore characterized by a playful eclecticism, in which no single style is dominant and many styles from the modern period and from the past can be used—even at the same time in the same work.

In place of purity and order, in postmodernism there is a mix of "high art" and popular culture. Fine art and commercial art styles can be combined together in a collage so that art appeals

to audiences of different levels of knowledge and understanding, and not just the intellectual elites in society.

A further characteristic of postmodern art is "intertextuality." This is when every "text"—a piece of literature, a pop video, or a movie, perhaps—relates to, alludes to, or comments on, various other "texts." Often this is done in an ironic way. Peter Blake's painting, *"The Meeting,"* or *"Have a Nice Day, Mr Hockney"* (1981–83), shows Blake, David Hockney, and Howard Hodgkin meeting each other at Venice Beach in California, and is a postmodern reworking of *Bonjour, Monsieur Courbet* (1854) by Gustave Courbet.

"Posties" (short for postmodernists) such as Jeff Koons use a wide range of kitsch imagery. Kitsch is art or artefacts characterized by a degree of vulgarity, sentimentality, and "bad taste." Koons's work can include Disney-type cartoon animals, shiny porcelain mantelpiece

"The Meeting," or "Have a Nice Day, Mr Hockney" **by Peter Blake** *1981–83. Oil on canvas. 39 x 49 in (99 x 124 cm). Tate Gallery, London.*

sculptures, plastic and inflatable flowers, and German baroque-style religious artefacts—especially angels.

Other important artists who have been labeled as postmodernists are the Scottish sculptor Ian Hamilton-Finlay, who has created a garden called "Little Sparta," where a model aircraft-carrier acts as a feeding table for birds; Pat Steir, who painted 64 panels reworking Pieter Bruegel the Elder's *Flowers in a Blue Vase* (1599) in 64 different artistic styles; and Stone Roberts, who paints large narrative paintings rather like 19th-century "conversation pieces."

Key artists:
Peter Blake (1932–), Ian Hamilton-Finlay (1925–), Jeff Koons (1955–), Robert Rauschenberg (1925–).

PRE-RAPHAELITE BROTHERHOOD

The Pre-Raphaelites were a group of British artists who came to prominence in the mid-19th century. Their early work may be classified as an offshoot of Romanticism, while that of their followers is related to symbolism and the Arts and Crafts movement.

The Pre-Raphaelite Brotherhood was formed in 1848 by seven friends. The leading figures were Dante Gabriel Rossetti, William Holman Hunt, and John Everett Millais, who all became successful artists. The other members were James Collinson, Thomas Woolner, a sculptor, and the critics F. G. Stephens and W. M. Rossetti.

The group wanted to breathe new life into artistic traditions, which they felt had become stifled by academic convention. Their choice of name emphasized this: at the time, Raphael was widely regarded as the greatest of all painters, and teachers at the art academies urged their students to emulate him. The Pre-Raphaelites were fervent admirers of the simpler style of earlier Italian artists (pre-Raphael), known as "primitives." They advocated careful observation of nature, and their pictures were often very detailed. Their favorite themes were medieval, religious, or literary, particularly those taken from authors preferred by the Romantics.

The Brotherhood first exhibited in 1849, some adding the initials "PRB" to their pictures. The paintings were generally well received but, when the secret of their association was made public, they were abused in the press, although there was support from the influential critic John Ruskin.

The Brotherhood was short-lived: Collinson resigned in 1850, and Woolner departed for Australia two years later. The remaining members soon chose different artistic directions (they were in their 20s when the group was founded). Millais gradually joined the mainstream, and became a successful portraitist. Hunt maintained the Brotherhood's precise, highly detailed style, but increasingly devoted himself to religious painting. However, *Isabella and the Pot of Basil* (1866–68) marked a rare return to his earlier style.

It was through the work and personality of Dante Gabriel Rossetti that the ideas of the Pre-Raphaelites progressed. He had never shared their concern for minute detail, but he developed the taste for mysterious, romantic subject matter. Increasingly, Rossetti concentrated on painting beautiful women in strange, evocative settings. He also had an undeniable charisma, which drew converts to the Pre-Raphaelite cause. The most influential of these were Edward Burne-Jones and William Morris, who had met at Oxford University. They became involved in Rossetti's scheme for painting a series of murals at the Oxford Union (the student debating society). Both men also took lessons from Rossetti, who proved a formative influence in their artistic careers.

As the leaders of the second wave of Pre-Raphaelitism, Burne-Jones and Morris gave the ideas of the original group an international dimension. Burne-Jones gained a huge reputation in France, where his sinuous, Italianate figures and his "subjectless" pictures proved an inspiration for the symbolist movement. Morris tried to revive medieval standards of craftsmanship in a bid to counter the growth of machine-based mass-production. He was a founding member of the Arts and Crafts movement, which flourished in Europe and the United States in the late 19th century.

Key artists:
Ford Madox Brown (1821–93), Edward Burne-Jones (1833–98), William Holman Hunt (1827–1910), John Everett Millais (1829–96), William Morris (1834–96), Dante Gabriel Rossetti (1828–82).

***King Cophetua and the Beggar Maid* by Edward Burne-Jones** *1884. Oil on canvas. 113 x 53 in (290 x 136 cm). Tate Gallery, London.*

PRIMITIVISM

The term primitivism was first used at the end of the 19th century, when it was used to describe the art of peoples who were outside the direct contact of the major centers of civilization. It was thought by many people in the Western world that these cultures were somehow "backward": less developed and less "civilized." This is why the arts of Black Africa, Oceania, pre-Columbian America, Native Americans, and Aboriginal Australians came to be referred to as primitive.

By the beginning of the 20th century, it was realized that the art of these cultures had much to offer, and primitive art began to attract the attention of the leading, modern European artists: Paul Gauguin was heavily influenced by the art of Tahiti, and other artists such as Pablo Picasso developed an interest in African art, especially masks. The influence can be seen in his painting *Les Demoiselles d'Avignon* (1907). The sculptor Henry Moore was impressed by the Mayan and Sumerian sculpture he found in the British Museum.

The term primitive can be applied as well to works of art from the early periods of European painting and sculpture, most often to works created before the Renaissance, because these works predate the use of scientific perspective in art. It can also describe artists who did not receive, or "absorb," the lessons of formal or professional artistic training. Instead, these mostly self-taught artists often painted in a manner that was highly personal in both style and treatment of subject matter. Examples of these "modern primitives" are Henri Rousseau and Grandma Moses, both of whom produced works of great power and inventiveness.

Key artists:
Constantin Brancusi (1876–1957), Grandma Moses (1860–1961), Henri Rousseau (1844–1910).

***The Repast of the Lion* by Henri Rousseau** *c1907. Oil on canvas. 44¾ x 63 in (114 x 160 cm). Metropolitan Museum of Art, New York, NY.*

REALISM

Realism was a specific movement within the history of art that began in France in the 1840s and lasted until about 1880. It is completely separate from the definition of "realism" that means the desire to copy nature faithfully without idealization or stylization (which is often used interchangeably with "naturalism").

The realist movement was a reaction against traditional subject matter, in favor of unidealized scenes of modern life. The leader of the movement was Gustave Courbet, who rejected popular religious, mythological, and historical paintings as subjects, because they depicted the past. Only the present should be represented: "Painting is an essentially concrete art," he said, "and can only consist of the presentation of real and existing things." Courbet wanted his paintings to shock the public, to be a deliberate protest.

Courbet's choice of subject matter and his frank, unidealized method of portrayal marked the beginning of a revolution. His paintings caused a scandal at the Salon and were seen as a "glorification of vulgarity." They were criticized for their ugliness and their unsuitable subject matter. *Funeral at Ornans* (1850) took an everyday subject—a burial—and gave it the status of a historic painting, which was deemed shocking. It shows unidealized rural people who are lifelike and life-size (it measures 10 x 22 feet). Equally shocking was the ugliness of the model used for *The Bathers* (1853), who is shown in a traditionally classical pose. Undeterred by the hostility shown toward his work, in 1855 Courbet held a one-man show in Paris, "Le Realisme, G. Courbet," which gave a name to the movement.

Another major painter of the realist movement was Jean-François Millet, best known for his images of peasants toiling in the fields. He aimed to give a solemn dignity to workers, glorifying their lives. In *The Gleaners* (1857) and *The Angelus* (1855–57) the peasants display an almost religious gravity. Millet's figures are more idealized than those of Courbet, but his subject matter and method of portrayal was equally new.

June Barricades by **Jean Meissonier** *1848. Oil on canvas. 11½ x 8½ in (29 x 22 cm). Musée National du Louvre, Paris.*

The demand for contemporaneity was the central issue of 19th-century French realism. While Millet's view of the world was a rural one, others such as Honoré Daumier turned to everyday urban life for their subjects: the noisy streets, public transport, theaters, and people going about their lives. *The Third Class Carriage* (c1862) shows a train filled with working-class passengers. They are portrayed in an unsentimental way with strongly characterized faces. A talented caricaturist, Daumier also contributed satirical and political cartoons to the newspapers.

The realist movement evolved during a time of great social change and unrest. The French Revolutions of 1830 and 1848; the ideologies of Karl Marx and Friedrich Engels; the philosophical writings of Pierre Joseph Proudhon and Charles Baudelaire; the novels of Emile Zola and Guy de Maupassant; and the invention of photography, which could permanently capture a fleeting moment—all contributed to raising public awareness about class distinction and the misfortunes of the poor. The desire to illustrate their plight—their miserable working conditions, and the hardship of poverty—was known as social realism, as seen in the sober illustrations by Gustave Doré.

While French in origin, realism spread throughout the Western world. In America, for example, it can be found in the work of George Bellows and Thomas Eakins.

Key artists:
George Bellows (1882–1925), Gustave Courbet (1819–77), Honoré Daumier (1808–79), Gustave Doré (1832–83), Thomas Eakins (1844–1916), Jean–François Millet (1814–75).

RENAISSANCE

The Renaissance is the name given to the major cultural and artistic revolution that began in Italy in the first decades of the 15th century and lasted until the 16th century. Its influence spread throughout much of Europe, and its effect on the development of art was so profound that it is seen as the turning point between the art of the medieval world and of the modern. The name, meaning "rebirth," refers to the revival of interest in antiquity that was at the heart of Renaissance ideas, and that was coupled with a desire to create a new and glorious era in the arts. This notion was first put into words in 1550 by

Giorgio Vasari in his important and influential book, *Lives of the Artists*.

Although the beginnings of the Renaissance can be traced back to the 14th century in the work of Giotto di Bondone, the movement really took off between 1420 and 1500, the period known as the early Renaissance. During this time a group of artists in Florence—Filippo Brunelleschi, Donatello, and Masaccio—consciously set out to recreate the art of the ancient and classical world in a way that was new and original. Their work was characterized by a much more lifelike depiction of the human body, set within a convincing and realistic space.

The Last Supper by Leonardo da Vinci
1495–98. Oil tempera on plaster. 179 x 343 in (460 x 880 cm). Santa Maria delle Grazie, Milan.

The leader of this group was Brunelleschi, a young architect whose ideas were extremely influential. He acquired an understanding of Roman engineering and construction methods while studying the ruins of antiquity. His great achievement was the building of the massive dome of Florence Cathedral, which could not have been built without such knowledge. Inspired by the Pantheon in Rome, the construction of the cathedral dome is

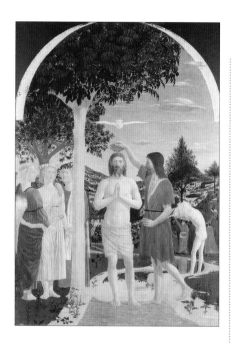

***The Baptism of Christ* by Piero della Francesca** *1440–50. Tempera on panel. 65 x 45 in (168 x 116 cm). National Gallery, London.*

of nature and the study of the human form. Donatello's figures appear to have been observed from live models rather than idealized "types"; this can be seen in his bronze statue of David (c1430s), the first free-standing nude since Roman statues. However, Donatello's figures have a new and powerful expressiveness and characterization.

The other founder of the Renaissance and an artist at the roots of modern painting was Masaccio. Inspired by the naturalism of Giotto, whom he greatly admired, Masaccio sought rational solutions to the problems of depicting figures in a convincing space. What was revolutionary was the way he applied the logic of perspective to his figures by using foreshortening. Also new was the way he used a constant light source to model his forms, building up the areas of tone to give them depth and solidity. This knowledge is well illustrated in his *Tribute Money* fresco for the Brancacci Chapel, Florence (c1425–28). The group of figures is convincingly portrayed within a landscape, and both obey the same laws of perspective. The figures' forms are solid and monumental, the faces are strongly individual, and they relate to each other and to the setting in lifelike poses, modeled by a naturalistic light.

Masaccio was a great inspiration to a host of talented painters of his own and following

generations. Fra Angelico, Paolo Uccello, Fra Filippo Lippi, Sandro Botticelli, Piero della Francesca, Andrea Mantegna, Antonio and Piero Pollaiuolo, and Giovanni Bellini are just a few artists synonymous with the Renaissance. Probably no other period in the history of art can boast the same wealth of achievement.

Florence continued to be the major center throughout the 15th century, with smaller regional schools springing up in Mantua, Siena, and Umbria, among other places. Artists closely followed the innovations of Masaccio and Donatello, and incorporated these into their individual styles. Fra Angelico applied the new methods to express traditional ideas of religious art. Paolo Uccello used fairly ambitious perspective in his lively and crowded battle scenes. The compositions of

***The Holy Family* by Michelangelo Buonarroti** *c1504–05. Tempera on panel. 46¾ in (120 cm) in diameter. Galleria degli Uffizi, Florence.*

an extraordinary feat of engineering. Rather than directly copying from the ancients, Brunelleschi followed their ideas about harmony and proportion, borrowed classical forms such as columns and pediments, and blended these into his buildings. Brunelleschi's other major contribution was to invent a technique for working out perspective using mathematical precision. This showed artists a way of reproducing a three-dimensional subject onto a flat surface within a convincing space.

This new understanding can be seen in the work of Donatello, the greatest sculptor of the early 15th century. His *Feast of Herod* (1423–27), a bronze relief for the baptistery font in Siena, uses the perspective of the background to enhance the drama of the scene in the foreground. The head of John the Baptist is brought into the dining hall and the guests recoil in horror, while background figures pass by seemingly unaware. Like Brunelleschi, Donatello assimilated the spirit of antiquity into his sculpture, but with a new purpose.

Among the preoccupations of classical artists had been the imitation

Piero della Francesca show much of the solemn grandeur of Masaccio, and a knowledge of perspective worked out with absolute mathematical precision. Other artists applied the new ideas to features such as light, color, drapery, and elegance of gesture, and took their subject matter from classical mythology—supremely illustrated in the work of Botticelli.

Around the turn of the century, the major center for art transferred to Rome and Venice. In Venice Giorgione and Titian became the leading painters. The period 1500–20, known as the High Renaissance, spans the time when a pure, classical balance was achieved in the work of Leonardo da Vinci, Michelangelo Buonarroti, and Raphael.

Leonardo da Vinci was one of the greatest, and most versatile, geniuses in the history of Western art. He perfected techniques of painting to such a degree that his tones blend imperceptibly. Leonardo made exhaustive studies of his subjects, filling his notebooks with beautiful drawings, from rapid sketches to capture the movement of a subject, to highly detailed anatomical studies. An artist, scientist, and philosopher, his range of accomplishments was awesome. Leonardo was also largely responsible for raising the status of the artist to that of creative thinker, not merely skilled craftsman.

The Renaissance concern with the expressive rendering of the human form was brought to its highest pitch by Michelangelo. To both painting and sculpture he brought a new and heroic style, charged with emotional expression. In the twisted poses in the Sistine Chapel ceiling frescos, Michelangelo attained the heights of perfection that artists had pursued since

Giotto, with the ability seemingly to "sculpt with his brush."

The Renaissance was not, however, a purely Italian phenomenon. In the north of Europe in the 15th century, the conquest of reality in art became a strong force, although the changes that occurred were more gradual and less deliberate and dramatic. Rather than breaking with past traditions, artists embellished them. One of the most celebrated painters of the Early Netherlandish School is Jan Van Eyck. He perfected the oil-painting technique to such a level of sophistication that his works were seen to "mirror nature itself." By applying layer upon layer of oil glazes, he achieved a high degree of realism in minute detail. His paintings abound with surface detail, saturated colors, and fantastically detailed landscapes. Several artists followed in Van Eyck's tradition, such as Rogier Van der Weyden, Dirk Bouts, Hans Memling, and Hugo Van der Goes. However, the ideals and imagery of the Italian Renaissance did not generally penetrate the north until about 1500.

The German Albrecht Dürer was the outstanding artist of the northern Renaissance. Having spent time in Italy studying the works of Renaissance artists, he was determined to transmit those ideas back to northern Europe. In addition to being a painter, Dürer was also a talented printmaker. He was the first artist of such stature to express himself primarily through engraving.

During the 16th century many young artists from northern Europe followed in Dürer's footsteps to Italy. By this time, the exaggerated poses and elongated figures of mannerism were replacing the Renaissance ideals of harmony and balance in Italy, and it is

A Man Aged Ninety-three by Albrecht **Dürer** *1521. Charcoal on colored paper heightened in white. 6.5 x 4.5 in (16.5 x 11 cm). Graphische Sammlung Albertina, Vienna.*

this style that was superficially imitated by these later northern artists. Those High Renaissance ideals were not to re-emerge until the 17th century, when certain aspects were incorporated into the new style known as baroque.

Key artists:
Early Renaissance: Fra Angelico (c1395/1400–55), Antonello da Messina (c1430–c1479), Giovanni Bellini (1431/36–1516), Sandro Botticelli (c1444/45–1510), Filippo Brunelleschi (1377–1446), Andrea del Castagno (c1421–57), Donatello (c1386–1466), Domenico Ghirlandaio (1448/49–94), Benozzo Gozzoli (1420/22–97), Fra Filippo Lippi (c1406–69), Andrea Mantegna (c1430–1506), Masaccio (1401–28), Piero della Francesca (1415/20–92), Antonio Pollaiuolo (c1432–98),

Paolo Uccello (c1397–1475), Andrea del Verrochio (c1435–88).
High Renaissance: Giorgione (c1477–1510), Leonardo da Vinci (1452–1519), Michelangelo Buonarroti (1475–1564), Raphael (1483–1520),

Titian (c1485–1576), Dirk Bouts (d1475), Jan Van Eyck (1395–1441), Hans Memling (c1435–94), Hugo Van der Goes (d1482), Rogier Van der Weyden (1399–1464).
Northern Renaissance: Albrecht Dürer

***The Madonna of Chancellor Rolin* by Jan Van Eyck** *1434–36. Oil on panel. 26 x 24 in (66 x 62 cm). Musée du Louvre, Paris.*

(1471–1528), Mathis Grünewald (c1470/80–1528).

ROCOCO

Rococo was a movement in the arts and architecture of 18th-century Europe that was characterized by a tendency toward lightness, elegance, delicacy, and decorative charm. The term is believed to derive from the French word *rocaille*, meaning rock- or shell-work, and was originally used to describe a style of interior decoration that made great use of S-shaped curves and scroll-like forms. Rococo was originally a term of ridicule, used to describe the fancy, flamboyant styles and tastes during the reign of Louis XV.

As a style of decoration, rococo is easy to define: it is colorful, light, and elegant—particularly when compared to the heavy baroque that preceded it. From about 1700 until the end of the 18th century, when it was superseded by neoclassicism, the rococo style dominated European art and design.

The paintings most often described as rococo are those by the French artists Jean-Antoine Watteau, François Boucher, and Jean-Honoré Fragonard. Watteau rejected the grand and serious subject matter of the late baroque, and effectively invented a new category of painting called *fête galante* (sometimes called *fête champêtre*). *Fêtes galantes* were fanciful scenes of elegantly dressed young people engaged in outdoor entertainment in pretty parkland settings, and became very popular in the 18th century.

The rococo painter, engraver, and designer François Boucher had been influenced by Giambattista Tiepolo, and in the 1740s was patronized by Madame de Pompadour, King Louis XV's mistress, whose portrait he painted several times. Through her influence, from 1765, Boucher became Court Painter to the king, and was much in demand as a painter of delicately colored, light-hearted decorative schemes that were often variations on pastoral or mythological themes, usually combined with a playful eroticism. The fanciful and artificial nature of rococo is reflected in Boucher's objection to painting from nature on the grounds that it was "too green and badly lit."

Jean-Honoré Fragonard began his professional career as a painter of works in the grand manner: heroic and aristocratic history paintings. He abandoned this style soon after 1765, and began to produce the smaller erotic canvases, such as *The Swing* (c1766), for which he is best known.

The rococo was not restricted to France. In Italy, Tiepolo was the most sought-after Italian painter of the period; he produced monumental decorative schemes for palaces and churches in Italy, Germany, and Spain. Tiepolo's allegorical pictures depicting scenes from the life of Cleopatra in the Palazzo Labia, Venice, show how he integrated decorative schemes into the architectural setting.

In England, Watteau's style was spread by the artist's arrival in London in 1719, and by a number of immigrant artists. This, combined with native traditions in portraiture, contributed to the development of the English genre of painting known as the "conversation piece." This is a portrait group in a domestic or landscape setting in which the sitters are either talking or engaged

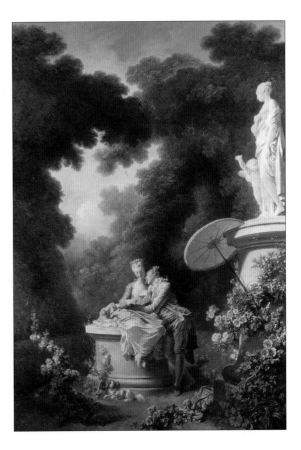

***Love Letters* by Jean-Honoré Fragonard**
c1771–73. Oil on canvas. 125 x 85½ in (317 x 217 cm). Frick Collection, New York, NY.

in some undemanding activity. The outstanding practitioners of this genre were Arthur Devis, William Hogarth (who also invented and popularized anecdotal picture series satirizing social abuses), and Thomas Gainsborough, who developed a personal style of light, rapid brushstrokes and a palette of delicate colors.

Key artists:
François Boucher (1703–70), Arthur Devis (1711–87), Jean-Honoré Fragonard (1732–1806), Thomas Gainsborough (1727–88), William Hogarth (1697–1764), Nicholas Lancret (1690–1743), Jean-Baptiste-Joseph Pater (1695–1736), Giambattista Tiepolo (1696–1770), Jean-Antoine Watteau (1684–1721).

ROMANESQUE

Romanesque is the name given to the art and architecture of Western Europe produced in the Middle Ages, from about the 10th century to the 13th century. The name Romanesque itself was actually devised in the 19th century and means "Roman-like." Originally it was used in relation to the buildings of the 11th and 12th centuries in Europe, which were like the thick-walled, vaulted structures built by the ancient Romans.

It is impossible to speak of a single or unified Romanesque style: during a 300-year period across Europe there were to be numerous stylistic variations due to local circumstances, traditions, materials, techniques, and influences. Nevertheless, there are certain identifiable characteristics of Romanesque art. There is an emphasis on pattern and decoration for its own sake; an emphasis on line and symmetry; a disregard for the anatomical or "correct" proportions of the human body—figures are squeezed or elongated in order to fit into the available space; and a tendency to make large-scale compositions deliberately "flat-looking," or two-dimensional. This was in order to emphasize the spiritual nature or content of the message in art, rather than making it look "real" and of this world.

The patrons of Romanesque art were the rich and powerful elite, the rulers of Church and State. Most of the Romanesque structures still in existence are therefore churches,

like the famous cathedral and belltower complex in Pisa, Italy (1063–1272), and castles, such as the Tower of London (1078–87, with later additions). The most characteristic feature of Romanesque architecture is the use of vaulting: spaces are covered by curving roofs of masonry (stone or brick) instead of the earlier post-and-lintel systems.

In sculpture, only a few freestanding works have survived: wars, religious dissent, and fires have all taken their toll. Most Romanesque sculpture was in fact designed as part of, and subordinate to, an architectural scheme, and a great deal of monumental sculpture exists in the forms of carved capitals and in the portal sculptures of church entrances. One of the finest examples is the *Christ in Majesty* tympanum (the triangular or semicircular area within an arch) over the south portal of the church of Saint Peter in Moissac, in France (c1125).

Inside churches, the large areas of stone walls and the curved areas of the vaults lent themselves to decoration using frescos or mosaics. Popular themes were the Ascent of Christ, the Last Judgment, and scenes depicting the Apocalypse.

Churches in the Middle Ages were associated with a particular religious order; these had their "headquarters" at monasteries, which became the centers of artistic production. Among the items they produced were ivory carvings, illuminated manuscripts, reliquaries (containers for sacred relics), and liturgical vessels (ewers, chalices, and plates used during religious services).

Key sites:
Cathedral, baptistery, and belltower of Pisa, Italy (1063–1272).

Key works:
Apse mosaic, church of San Clemente, Rome (c1125); *Adoration of the Magi*, 12th-century whalebone ivory carving (Victoria and Albert Museum, London); Abbot Sugar Cup (c1140), National Gallery of Art, Washington; Eltenburg Reliquary (c1180), Victoria and Albert Museum, London.

The cathedral and belltower, Pisa.
Built between 1063 and 1272, the Romanesque complex in Pisa consisted of the cathedral, the baptistery—and the belltower, now famous as the "leaning tower of Pisa."

ROMANTICISM

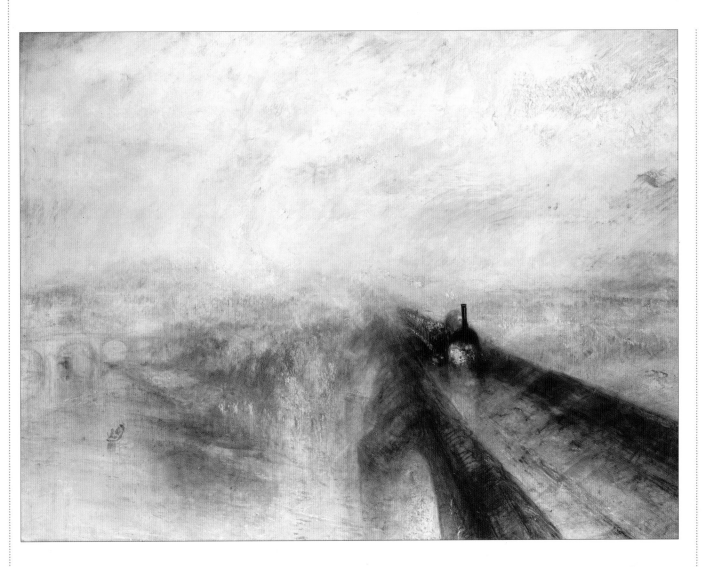

Romanticism was a multifaceted movement affecting all branches of the arts. It emerged in the late 18th century and blossomed fully in the first half of the 19th century. It assumed many forms, but in general can be seen as a reaction against order and reason—the two principal values of the Enlightenment and neoclassicism.

The word "romantic" was in popular use long before the start of the movement. It described anything that conjured up the mood of the old "romances," which had circulated in the Middle Ages. These were a series of tales involving chivalrous knights and heroic deeds. It was common, therefore, to describe a castle or a fairytale as "romantic." This application of the word increased greatly in the 19th century, when there was a resurgence of the Gothic style, pioneered by architects such as August Pugin and Eugène Viollet-le-Duc; in literature there was a vogue for tales of medieval knights, popularized by Sir Walter Scott; and similar themes were tackled in painting, most notably by the artists of the Pre-Raphelite Brotherhood.

In the late 18th century, however, a group of German writers, led by Johann Von Schiller, Johann Von Goethe, and

Rain, Steam, and Speed—The Great Western Railway by J. M. W. Turner
c1839–44. Oil on canvas. 35¾ x 48 in (90.5 x 122 cm). National Gallery, London.

Friedrich Von Hardenberg (known as Novalis), began to shift the emphasis of the word. They used it to stress the power of imagination and emotion, and the importance of the individual. These qualities—imagination, emotion, and individualism—lie at the heart of Romanticism.

The emphasis on the imagination led artists to explore areas beyond the scope of reason. There was an upsurge

of interest in the macabre, in the exotic, in visions, and delusions. Both Théodore Géricault and Francisco Goya examined the theme of madness (a subject rarely addressed before this period); Goya also illustrated scenes of witchcraft and superstition. The quest for the exotic gave rise to Orientalism; this was a subdivision of the Romantic movement. Western artists produced colorful depictions of Eastern culture, from observation or their imagination.

The emphasis on individuality often involved a spirit of rebellion. The Romantic era witnessed a number of uprisings, including the French Revolution (1789). For the Romantics, the most important of these was the Greek War of Independence (1821–32), since it affected the cradle of European civilization. The conflict inspired moving paintings by Eugène Delacroix, while the poet Lord Byron actually went off to fight in the war.

Romanticism also influenced the art of landscapists. In the past, they had taken sketches and then composed their landscape in the studio, imposing their own sense of order upon nature. The Romantics, in contrast, felt dwarfed by the power and violence of nature. Their landscapes, typified by the work of J. M. W. Turner, are full of raging storms and howling gales.

Key artists:
William Blake (1757–1827), John Constable (1776–1837), Eugène Delacroix (1798–1863), Caspar David Friedrich (1774–1840), Henry Fuseli (1741–1825), Théodore Géricault (1791–1824), Francisco Goya 1746–1828), Philipp Otto Runge (1777–1810), J. M. W. Turner (1775–1851).

STIJL, DE

Founded in 1917, with a name that simply means "style," De Stijl was a loose association of Dutch painters, architects, and furniture designers. The group's aim was simple but sweeping: to create an inclusive modern style to suit every aspect of life. "The object of nature is man. The object of man is style," they wrote. Art and life would become one, they believed, and everything "from teacups to town plans" would reflect a total harmony of vision.

The self-taught painter Theo Van Doesburg was the association's main organizer and publicist. He provided the impetus for their magazine, *De Stijl*, which had a tiny circulation of 300, but with an international distribution made a huge impact on interior design.

Van Doesburg and the abstract artist Piet Mondrian began the association, along with the architect Gerrit Rietveld, who designed the Red-Blue Chair in 1917. With its black frame composed of straight interlocking lines, and its use of primary colors, it formed a symbol for the movement, and gave the artists the color scheme that became their hallmark. They painted in a uniform style, using the three primary colors (red, yellow, and blue), and three noncolors (white, black, and grey) in arrangements of rectangles.

The artists' studios formed part of their scheme for living as well: they were more laboratories than creative workshops. Every detail of their rooms was in keeping with the streamlined, linear vision. Artist Willem de Kooning

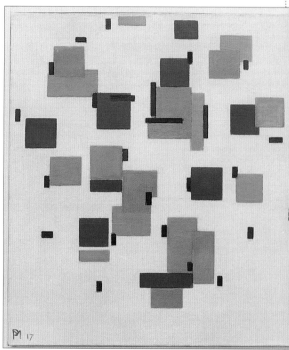

***Composition in Color 8* by Piet Mondrian**
1917. Oil on canvas. 19 1/2 x 17 3/4 in (50 x 45 cm). Rijksmuseum Kröller-Müller, Otterlo.

once remarked that visiting Mondrian's studio was like "walking around in one of his paintings."

Mondrian left De Stijl in the mid-1920s, when Van Doesburg started to include diagonals in his paintings. Van Doesburg later redesigned the Cinema Dance Hall in Café d'Aubette in Strasbourg, France. When the café re-opened, the public hated it, forcing the management to make alterations.

De Stijl formally ended with Van Doesburg's death in 1931. However, it greatly influenced modern architecture, furniture design, and typography.

Key artists:
Piet Mondrian (1872–1944), Gerrit Rietveld (1888–1964), Bart Van der Leck (1876–1958), Theo Van Doesburg (1883–1931).

SURREALISM

Taking as a starting point many of the ideas and practices of dadaism, surrealism developed into a more disciplined movement in art and literature. Surrealism was not a style, but rather a carefully thought-out struggle against "normal," everyday, rational thought processes and the superficial imagination. The surrealists wanted revolution, not only of a political kind, but of the mind and of ways of thinking. In order to conduct this struggle, the surrealists did all they could to excavate, draw from, and stimulate the very deepest, unconscious parts of the human mind.

André Breton, a writer who had worked with the sick and wounded in the war and was interested in new ways of investigating mental illness, formulated most clearly the principles of surrealism. He published his "Surrealist Manifesto" in Paris in 1924, and the first of several surrealist exhibitions was held the following year. Breton said that the surrealist movement was intended to "resolve the previously contradictory conditions of dream and reality into an absolute reality, a super-reality."

Breton and other surrealists were fascinated by the methods of the famous psychoanalyst Sigmund Freud. Freud had analyzed the human unconscious and the meaning of dreams. Now the surrealists tried to tap into these hidden fields. They used the imagery of dreams, and of fleeting, nonsensical thoughts as the basis for their work. They were interested in the drawings and writings of children and the insane. Most importantly, however, they explored "automatism." To do this, they conducted experiments in which they attempted to write or draw

The Conqueror by **René Magritte** *1926.*
Oil on canvas. Dimensions unavailable.
Private collection.

"automatically," without planning, without thinking, and without conventional logic.

The results amazed and inspired them. Many surrealist drawings, paintings, and poems are based on "automatist" exercises. In an attempt to prevent one artist's intention from determining an image, Breton and his friends played a game where each drew one part of a figure without seeing the whole. The results were called "exquisite corpses," and indeed produced some remarkable images.

Surrealist artists were inspired by the work of Giorgio de Chirico, co-founder in 1917 of the group Pittura Metafisica ("Metaphysical Painting"). The strange, deserted spaces, abandoned statues, and curious combinations of objects in his paintings defied logic and therefore appealed to the surrealists.

Surrealist artworks are extremely diverse; they range from the meticulous illusions of Salvador Dalí to the witty visual puns of René Magritte, the bizarre, sometimes ominous images of Max Ernst, and the playfulness of Joan Miró's. In the 1930s the movement spread across Europe and, during World War II, when many European surrealists went into exile in the United States, it became truly international, involving artists such as Arshile Gorky, Jackson Pollock, and, in Mexico, Frida Kahlo.

Key artists:
André Breton (1896–1966), Salvador Dalí (1904–89), Max Ernst (1891–1976), René Magritte (1898–1967), Man Ray (1890–1977), André Masson (1896–1987), Joan Miró (1893–1983), Meret Oppenheim (1913–85).

SYMBOLISM

Symbolism was the last important movement in the arts of the 19th century. The term describes a general tendency, or even a "mood" in the arts, which emerged first in the 1880s in France among poets such as Stéphane Mallarmé. These writers put into words what many artists were already feeling: that art had become too commonplace and dull. For many years, progressive artists had only painted "real," modern subjects. The symbolists thought that these works lacked feeling or imagination. They longed for a return to the values of Romanticism and an art that was emotional, imaginative, and drew on the fantasy of the artist or the poet.

Symbolism took different forms in the work of different artists. In France it ranged from the restrained calm of the paintings of Pierre-Cécile Puvis de Chavannes to aspects of Paul Gauguin's imagery and the lush, jeweled excesses of Gustave Moreau. In Austria Gustav Klimt's elegant, decorative visions were influenced by symbolism. In Switzerland Arnold Böcklin and Ferdinand Hodler, though they are very different artists, can both be described as symbolists. Farther north, in Belgium, James Ensor's vivid and macabre fantasies show many symbolist tendencies, and in Norway, Edvard Munch's expressive paintings of human experience formed an important link between the symbolism of the 19th century and the expressionism of the 20th century.

Symbolist works often seek to create a particular atmosphere or evoke memories or emotions such as sadness. Favorite subjects for many symbolist artists were medieval legends, fantastic creatures from ancient myths, and the more exotic passages from the Bible. Hence, hybrid creatures such as unicorns, minotaurs, sphinxes, and mermaids often appear, set in timeless, misty landscapes, deserted spaces, or seascapes. Another key figure in symbolist art and literature was that of the "femme fatale," or deadly woman. Most often these were beautiful, exotic women from the Old Testament—Salome, Judith, or Delilah—who used their feminine charms to fool, harm, or kill men. Such figures appear especially in the work of Klimt and Moreau. In these images, the story itself is often less important than the atmosphere of the scene or the rich surface decorations and the surroundings. Perhaps not surprisingly, many symbolist artists admired the British Pre-Raphaelites for the "visionary" qualities of their work, the beautiful, enigmatic women they portrayed, and the close attention they paid to symbolic details.

As the century drew to a close, other artists emerged whose work was related to the symbolist movement: Ferdinand Hodler, and Munch. These younger artists often drew on symbolist themes and were also concerned with evoking moods, memories, or emotions. The early work of Pablo Picasso, in his so-called "blue period," also showed many symbolist influences. However, these artists drew more on personal experience for their subjects, and used more extreme, non-naturalistic colors and forms. As such they formed a link between symbolism and cubism, or the more spontaneous expressionism.

Key artists:
Arnold Böcklin (1827–1901), Paul Gauguin (1848–1903), Ferdinand Hodler (1853–1918), Gustav Klimt (1862–1918), Gustave Moreau (1826–98), Edvard Munch (1863–1944), Pierre-Cécile Puvis de Chavannes (1824–98), Odilon Redon (1840–1916).

***Spring* by Odilon Redon** *1906–08. Oil on canvas. 21 1/2 x 30 in (54.5 x 73.5 cm). Worcester Art Museum, Worcester, MA.*

UTRECHT SCHOOL

The Utrecht school is the name of a school of painting in the Dutch Republic in the late 16th and 17th centuries. Most of the large cities had flourishing schools at this time, but what distinguished the Utrecht school painters was that—in addition to producing portraits, genre scenes, still lifes, and landscapes—they also produced religious and mythological pictures. It was the art of Italy, and later of France, that made the Utrecht school style unique. Utrecht had a long Catholic tradition and strong links with Rome, and these affected both the types of pictures painted and their styles.

Two of the Utrecht painters who were especially important were Abraham Bloemaert and Joachim Wtewael. Bloemaert was responsible for the training of many of the second generation of Utrecht school painters. He was a skillful painter who created small works as well as life-sized paintings. In both he demonstrated his virtuoso handling of anatomy, foreshortening, and composition.

Early in the 17th century, a number of artists traveled to Rome. They later came back to Utrecht, bringing with them a style that would transform the city's art: the style of Michelangelo Merisi da Caravaggio. Chief among the "Caravaggesque" painters were Hendrick Terbrugghen, Dirck Van Baburen, and Gerrit Van Honthorst.

Terbrugghen painted large-scale religious works, but his favorite subjects were really musicians, singers, and "low-life" characters. His technique, in particular his modeling of soft edges, a subtle palette, and single-figure formats (often with the figure seen from the back), were to be of great influence on the early works of Jan Vermeer.

Honthorst, like Caravaggio, was fascinated by the effects of light, often using light emanating from a candle or a fire in his paintings. Baburen was the closest of the Utrecht painters to Caravaggio in terms of composition. He used half-length figures derived from Caravaggio's religious works, but adapted for use in secular paintings.

Subsequently a second wave of young painters returned to Utrecht from Rome; these included, in 1641, Jan Both. He brought to Utrecht a style that was to become universally popular. The landscapes that Both painted show carefully balanced trees and distant hills bathed in the soft, transparent, golden light of the setting sun. Both had borrowed this lighting effect from the landscapes of Frenchman Claude Lorraine, who had been working in Rome at the same time as him.

***A Rocky Italian Landscape* by Jan Both**
Mid-1640s. Oil on canvas. 40½ x 49¼ in (103 x 125 cm). National Gallery, London.

At the end of the 17th century the French landscape style dominated in Utrecht; a leading exponent was Jacob de Heursch. He produced technically brilliant paintings in the "French manner." There was a great demand for these following the French invasion of the Dutch Republic in 1672.

Key artists:
Abraham Bloemaert (1564–1651), Jan Both (c1618–52), Jacob de Heursch (1656–1701), Hendrick Terbrugghen (1588–1629), Dirck Van Baburen (c1595–1624), Gerrit Van Honthorst (1590–1656), Cornelius Van Poelenberg (c1594–1667), Joachim Wtewael (1566–1638).

GLOSSARY

Using the glossary
Abbreviations: (adj.) adjective, (arch.) architectural term; (Fr.) French; (Ger.) German; (Gr.) Greek; (It.) Italian; (Jap.) Japanese; (Sp.) Spanish. Words set in SMALL CAPITALS denote headings of related entries in the glossary. An * indicates that the entry is illustrated.

A

abstract art art that does not represent any recognizable subject matter, and that exists for its own sake, using form and color for expressive effect. Also, **abstraction**. *See also* CONSTRUCTIVISM, RAYONISM, SEMIABSTRACTION.

abstract expressionism a form of ABSTRACT ART that developed in New York in the 1940s. Its characteristics are the expressive use of paint to convey strong emotions, and large canvases. It became a dominant movement during the 1950s and is particularly associated with Jackson Pollock and Arshile Gorky. *See also* NEW YORK SCHOOL.

Abstraction-Creation (Fr.) **1** group of abstract artists in Paris in 1931 who promoted nonrepresentational art through their exhibitions. **2** the annual magazine published by the group from 1932 to 1936; its full title was *Abstraction-Creation: Art non-figuratif.*

academic art art conforming to the principles of the Academy, the art institution that set specific

TYPES OF ALTARPIECE

ideals governing works of art. Academic art tends to be quite traditional and conservative. Anti-academic art sets out to oppose those values and pursue originality, expressive freedom, and a choice of subject matter and TECHNIQUE.

Academy word derived from Plato's Academy, a school of philosophy. During the RENAISSANCE the term was adopted by literary and philosophical groups, and later by schools for training artists. These academies were characterized by their emphasis on the study of CLASSICAL art and the human form. In the 19th century the academies were associated with conservatism, and their values were rejected by many artists who sought alternative creative outlets.

acrylic a type of synthetic RESIN polymer. Used in EMULSION form as a modern painting medium, and in sheet form in modern sculpture. *See also* PLEXIGLAS.

action painting term coined in 1952 by American critic Harold Rosenberg to describe the type of ABSTRACT EXPRESSIONISM practiced by Jackson Pollock and others, in which the emphasis was on the action of applying paint, sometimes splashing or pouring it over a canvas on the floor.

aerial perspective the expression of space in a painting by the gradation of color and distinctness.*

aesthetic, aesthetics, aesthetic movement *see* ESTHETIC, etc.

Aerial perspective
The background colors and tones are made progressively bluer and lighter as they recede into the horizon. This creates an illusion of distance and atmosphere.

all'antica (It. "in the antique style") STYLE of works of art, especially sculpture, that imitate ANTIQUE models.

alla prima (It. "at first") a TECHNIQUE, commonly used in painting since the 19th century, whereby an artist completes a painting in one session without creating layers of UNDERPAINTING.

allegory image with an underlying meaning which is expressed symbolically. Also, **allegorical**. Allegorical paintings were popular during the RENAISSANCE and BAROQUE periods,

altarpiece in Christian CHURCH architecture, a picture or decorated screen on or behind the altar. It may consist of a single painting or an elaborate group of hinged panels.

See also DIPTYCH, POLYPTYCH, *PREDELLA*, TRIPTYCH.*

American regionalism *see* REGIONALISM.

amphitheater semicircular arena surrounded by tiered seats. Used from the 1st century BC throughout the Roman world and into modern times for public spectacles.

analytical cubism early phase of CUBISM, c1907–1912, in which natural forms were analyzed and fragmented into their essential GEOMETRIC parts.

anamorphosis distorted image of a subject drawn in such a way that it is recognizable only if seen from a particular viewpoint or by means of a special curved mirror. A well-known example is the skull in the FOREGROUND of Holbein's *The Ambassadors* (1533).*

anatomy structure of an organism or any of its parts. Refers to plants or animals.

antique the remains of Greek and Roman civilization (mainly architectural and sculptural) that date from before the fall of the Roman Empire in the 5th century AD. During the RENAISSANCE Greek and Roman sculpture was admired as an IDEAL ART and has been a constant source of inspiration for

***Altar with* predella**

Diptych

Triptych

Polyptych

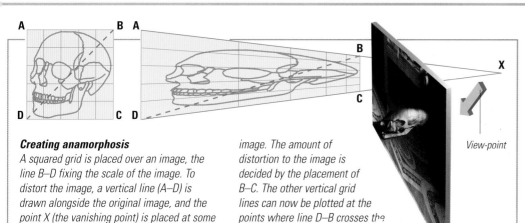

Creating anamorphosis
A squared grid is placed over an image, the line B–D fixing the scale of the image. To distort the image, a vertical line (A–D) is drawn alongside the original image, and the point X (the vanishing point) is placed at some distance to the right. Lines are drawn to connect A, D, etc. to X and "stretch" the image. The amount of distortion to the image is decided by the placement of B–C. The other vertical grid lines can now be plotted at the points where line D–B crosses the horizontal lines, and the image is drawn to the grid.

View-point

artists since the Renaissance; study of the antique formed the basis of the curriculum in most art academies. Also, **antiquity**.

apotheosis (Gr. "deification") in CLASSICAL art this represented the entry into Olympus of a famous or heroic figure. In the BAROQUE period it was a popular theme for depicting, in an ALLEGORICAL manner, the glorification of the artist's PATRON, usually a prince.

applied art the designing and decorating of functional objects or materials to give them ESTHETIC appeal, e.g. CERAMICS, glass, printing type, furniture, textiles, and METALWORK. The term is frequently used to differentiate this type of work from the FINE ARTS (painting, drawing, sculpture).

apse (arch.) semicircular or polygonal end of a CHURCH; usually the end of the CHANCEL, at the east end of the church.

aquatint ETCHING process whereby acid is allowed to "bite" into a metal (usually copper) PLATE that is prepared with RESIN. The plate is then inked and printed.

arcade (arch.) continuous series of arches supported by COLUMNS.

Arcadia rural area of the Peloponnese in ancient Greece, idealized in the writings of Virgil, which in the RENAISSANCE came to represent an idyllic life of PASTORAL and simple pleasures. Also, **arcadian**.

archaic 1 art of the ARCHAIC GREEK period. **2** antiquated, out of date.

Archaic Greek art Greek art of the mid-12th century BC to c480 BC; one of four convenient divisions of Greek art, the others being GEOMETRIC, CLASSICAL, and HELLENISTIC.

architecture 1 the science or art of building. **2** the structure or STYLE of what is built.

armature wire or wood framework or skeleton on which a sculptor MOLDS his clay.

Armory Show international exhibition of modern art held in the 69th Regiment Armory building in New York in 1913. Exhibits included the work of the more AVANT-GARDE American artists and of the SCHOOL OF PARIS. The exhibition was enormously popular and marked the birth of a real interest in modern art in the United States in the 20th-century.

Art for Art's Sake *see* ESTHETIC MOVEMENT.

arriccio (It.) coat of PLASTER made from LIME and sand used in preparing a wall for painting (especially in FRESCO). A smooth layer of lime plaster (*INTONACO*) was applied on top.

art deco fashionable STYLE of western ARCHITECTURE, APPLIED ARTS, interior, and graphic design of the 1920s and 1930s, characterized by the combination of decorative ART NOUVEAU with new GEOMETRIC forms.

artifact (or artefact) **1** an object of human workmanship. **2** (archaeology) an object created by humans and remaining from a particular period; for example, a PREHISTORIC artifact.

art nouveau (Fr.) decorative STYLE popular in Europe in the late 19th and early 20th century; it often employed stylized, CURVILINEAR plant forms. It was known in Germany as JUGENDSTIL.

Arts and Crafts movement mid-19th-century artistic movement, originating in England and spreading to continental Europe and the United States, that was inspired by John Ruskin and William Morris. It attempted to raise the standards of design and craftsmanship in the APPLIED ARTS, and to reassert the craftsman's individuality in the face of increasing mechanization.

a secco *see* SECCO PAINTING.

Ashcan school term used to describe the REALIST group of artists that evolved from THE EIGHT in New York about 1908. The group drew its main inspiration from Robert Henri, and its members usually took as their subject everyday, urban life.

assemblage modern art form consisting of objects collected and presented together. Components are preformed, not made by the artist, and not intended originally as "art material." *See also* JUNK SCULPTURE.

atelier (Fr.) studio or WORKSHOP.

automatism drawing and painting method associated with SURREALISM in which the artist does not consciously create but doodles, allowing the subconscious mind and virtually uncontrolled movement of the hand to produce an image.

automatist 1 an artist who practices AUTOMATISM; **2** (adj.) the work thus produced.

avant-garde artists whose work is ahead of that of most of their contemporaries; unconventional, experimental, innovative. Also descriptive of the work produced by such artists. The term was first applied to art by critic Théodore Duret in the late 19th century.

B

bacchanal mythological scene popular in paintings of the RENAISSANCE and 17th century depicting the revels of Bacchus, Roman god of wine. *See also* GODS AND GODDESSES.

Ballet Russe hugely successful and influential ballet company formed by the Russian impresario Sergei Diaghilev in 1911. The company was characterized by a flamboyant fusion of dance, design, and music.

baptistery place where baptism is performed in CHURCH. In early Christian and medieval times separate buildings were erected and the term applied to them.

Barbizon a village in northern France, on the edge of the forest of Fontainebleau, which became

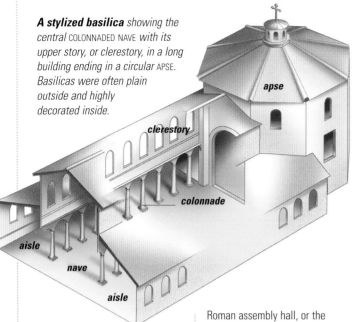

A stylized basilica showing the central COLONNADED NAVE *with its upper story, or clerestory, in a long building ending in a circular* APSE. *Basilicas were often plain outside and highly decorated inside.*

apse

clerestory

colonnade

aisle

nave

aisle

a popular site for artists during the 1840s.

Barbizon school a group of French LANDSCAPE painters of the mid-19th century who painted landscape, often directly from nature. It included Théodore Rousseau and Charles-François Daubigny.

baroque 1 STYLE of ARCHITECTURE, painting, and sculpture originating principally in Italy, of the late 16th to the early 18th century; it exhibited an increased interest in DYNAMIC movement and dramatic effects. The style reached its peak in c1625–75, when it became known as High Baroque. **2** over-elaborate, florid. **3** period in the 17th century when the baroque style was at its height.

baroque classicism CLASSICAL STYLE—exemplified in the paintings of Nicolas Poussin and the ARCHITECTURE of Carlo Fontana —that flourished during the BAROQUE period. Characteristic of the style are a methodical approach based on rules derived from the CLASSICAL past.

basilica (arch.) medieval church in which the NAVE is taller than the aisles. Early churches had an APSE at one end. It was based on the

Roman assembly hall, or the design of colonnaded halls in private houses.*

Bauhaus highly influential school of ARCHITECTURE and modern art, founded in Weimar, Germany in 1919 by Walter Gropius. The Bauhaus became the focus of modern design, advocating clean, simple lines and plain surfaces, and establishing a clear relationship between design and industrial technology. The school was closed by the Nazis in 1933.

belle époque (Fr. "beautiful age") period of high artistic and cultural development around the end of the 19th century. *See also* FIN DE SIÈCLE.

Berliner Sezession (Ger. "Berlin Secession") group of artists, led by the German impressionist painter Max Liebermann, who broke away ("seceded") from the official institutions in Berlin to organize their own exhibitions. The work of DIE BRÜCKE artists were among those who exhibited in 1908. *See also* SEZESSION.

biennale major art exhibition held every two years, often of international importance. The most famous is the VENICE BIENNALE.

biomorphic refers to any DECORATIVE form that represents a

living subject. ("Morph" means shape.)

biting ETCHING term describing the treatment of a PLATE with acid to etch lines in it. *See also* STOPPING OUT.

Blaue Reiter, Der (Ger. "The Blue Rider") group of artists formed in Munich in 1911 by Wassily Kandinsky and Franz Marc. The group was of varied outlook; other artists who joined it included Paul Klee, Georges Braque, and Pablo Picasso.

board stiff paper made from cheap fibers. Boards have been used instead of canvas or paper as painting supports since the 19th century; types include academy board and canvas board.

bodegón (Sp. "tavern;" plural bodegónes) painting of a kitchen scene with a predominant interest in STILL LIFE.

body color 1 WATERCOLOR made OPAQUE by mixing with white. **2** term used in painting to describe solid, definitive areas of color that are then completed or modified with SCUMBLES and GLAZES.

Bohemian someone who leads an unconventional lifestyle. (Bohemia was an ancient central European province.)

Book of Hours book of prayers to be said at canonical hours, used privately by people in their homes. It was common in the 15th century and sometimes richly ILLUMINATED.

bottega (It.) shop, WORKSHOP, or artist's studio.

bozzetto (It.) small-scale MODEL in WAX or clay of a larger sculpture. It can be used for painted SKETCHES as well. Also called MODELLO.

bravura STYLE that demonstrates technical or artistic flair or brilliance.

bronze 1 alloy of copper and tin, often used for cast sculpture.

2 a sculpture made from this alloy. **bronze casting** *see* CIRE PERDUE.

Brücke, Die (Ger. "The Bridge") group of German expressionist painters founded in Dresden in 1905, including the artists Ernst Ludwig Kirchner and Karl Schmidt-Rottluff. It was dissolved in 1913.

brushstroke individual mark made by each application of paint with a brush, usually retaining the mark of the separate brush hairs.

brushwork general term for manner or STYLE in which paint is applied, and often considered by art historians as an identifying characteristic of a particular artist's work.

buon fresco (It.) *see* FRESCO.

buttress (arch.) reinforced projecting wall, usually on the exterior of a building, supporting it at a point of stress. *See also* FLYING BUTTRESS.

Byzantine art art of the eastern Roman Empire centered on Constantinople (formerly known as Byzantium, now Istanbul, Turkey) from the 4th century AD.

C

cabinet picture small or medium-sized painting executed at an easel, and designed for collectors, especially popular from the 17th century. *See* EASEL PAINTING.

Camden Town group English POSTIMPRESSIONIST painters formed in 1911 around Walter Sickert, and named after an area of north London. The group included Spencer Gore and Augustus John. They painted small, suburban scenes of contemporary London, using bold, flat areas of color.

camera obscura device that uses a lens to project an image of an object on to a flat surface so that the outline may be traced. Popular with artists from the RENAISSANCE to the 18th century.*

Light from the scene is focused by the lens onto a mirror.

The mirror, angled at 45 degrees, reflects the image on to a ground-glass screen.

The image on the screen can be traced accurately.

The camera obscura, which Canaletto is thought to have used, had been in existence from the 16th century and was the forerunner of the modern camera. PHOTOGRAPHY, as we know it today, began when ways of fixing the image with chemicals were announced in Paris in 1839. The French painter Paul Delaroche believed that the new process would mean the death of painting.

charcoal form of carbon used for DRAWING.

chase 1 to ornament a METAL surface by ENGRAVING with steel tools. **2** to apply the final smoothing to a BRONZE CAST. Both processes are known as **chasing**.

chiaroscuro (It.) PICTORIAL use of LIGHT and shade to convey shadow and highlight three-dimensional form. It is mostly associated with 17th-century artists.

Chicago school group of architects working in Chicago between 1871 and 1893 that included Frank Lloyd Wright and Louis Sullivan.

choir (arch.) part of CHURCH where service is sung.

chromatic of, or relating to, color.

church 1 building designed for Christian worship. The first churches were based on the Roman BASILICA. **2** the whole body of Christian believers.

cinnabar red mercuric sulfide used as a PIGMENT. Artificial cinnabar is usually called vermilion.

cinquecento (It.) the 16th century.

cire perdue (Fr. "lost wax") CASTING process used in BRONZE sculpture.*

classic 1 the finest art of its kind in any given period. **2** Greek art and ARCHITECTURE of the 5th century BC. **3** art of the Roman and Greek ANTIQUE world. **4** art that adheres to high standards of craftsmanship, PROPORTION, symmetry, and logic.

classical synonymous with CLASSIC (2, 3, and 4).

classicism characterizes art that follows established ESTHETIC ideas. During the 18th and 19th centuries, it was held to represent the qualities of restraint and harmony, in contrast to dramatic individual expression, and was thus in opposition to ROMANTICISM.

cloister (arch.) covered walk around a space, usually square, with a wall on one side and

campanile (It.) (arch.) free-standing bell tower of a CHURCH.

capital (arch.) upper part and crowning feature of a COLUMN or PILASTER. Columns are categorized according to the STYLE of decoration on a capital: Ionic, Doric, Corinthian, Tuscan, or Composite.*

capriccio (It. "fancy" or "caprice") in the 18th century it usually referred to a painting in which accurately rendered, real ARCHITECTURE was combined with the imaginary, as in, for example, Canaletto's scenes of Venice. It also applied to ETCHINGS that represented fantasies rather than actual stories.

Caravaggism tendency to follow the STYLE of Caravaggio, exhibited by the **Caravaggisti** (17th-century painters working in Rome), who made particularly dramatic use of CHIAROSCURO. See also NATURALISM.

caricature painting or DRAWING, usually a PORTRAIT, that exaggerates the features of the subject for humorous or satirical effect. The 19th-century French artist Honoré Daumier was an outstanding political **caricaturist**.

cartellino (It. "little paper") an ILLUSIONISTIC device in the form of a small piece of paper or SCROLL, painted in the FOREGROUND of a work of art, and often containing a painter's signature or a motto.

cartoon 1 full-sized preparatory DRAWING from which a design is traced or copied on to a painting, MURAL, or TAPESTRY. **2** humorous drawing; CARICATURE.

casting a method of duplication of a MODEL in METAL or PLASTER by means of a MOLD; the model thus formed is a **cast.**

catalogue raisonné (Fr. "reasoned catalogue") descriptive catalogue that, when applied to an artist, lists their works in systematic order.

ceramics the general term used since the 19th century for pottery and PORCELAIN, or any FIRED clay. Also, **ceramist**, one who makes ceramics.

Cercle et Carré (Fr. "Circle and Square") group and periodical of international constructivists, formed in Paris in 1929 by Joaquin Torres-Garcia and others to promote ABSTRACT ART. See also CONSTRUCTIVISM.

chancel (arch.) east end of CHURCH containing the altar.

Cire perdue—the lost wax process
1. A model is made, typically of clay.

2. A cast of the model is made.

3. The inside of the cast is coated with WAX to the thickness of the intended bronze. The cast is then removed to reveal a hollow wax figure.

4. The wax figure is filled with liquid PLASTER to form a core. Wax "runners" are attached.

5. Plaster is poured over the figure. When heated in an oven, the plaster dries and the melted wax escapes (runs out) through the runners. Molten bronze is then poured into the plaster cast to replace the "lost" wax.

6. The outer plaster and core are removed and the runners are sawn off before the finishing process.

COLUMNS on the other. In Christian monasteries it often links the CHURCH and domestic quarters.

cobalt metallic element from which colored pigments were produced in the 19th century.

collage (Fr. "pasting") TECHNIQUE originating with CUBISM in which paper, photographs, and other everyday materials were pasted onto a support, and sometimes also painted.

Cologne school paintings from the Cologne region of Germany, dating from the late 14th to 16th centuries.

Colonial style American painting, art, and ARCHITECTURE of the 17th to 19th centuries.

colonnade row of COLUMNS. *See also* PORTICO.

color-field painting painting, usually on a large scale, in which solid areas of color are taken up to the edge of the canvas, suggesting that they extend to infinity. Developed in the United States in the 1940s and 1950s, a leading exponent was Mark Rothko.

colorism term applied to various historical periods of painting (e.g. 16th-century Venetian) in which color was emphasized rather than DRAWING.

colorist artist who specializes in, or is famed for his/her use of color.

TYPES OF COLUMNS

cornice
frieze
architrave
capital

column

base

Doric **Ionic** **Corinthian** **Tuscan** **Composite**

column (arch.) cylindrical PILLAR, either freestanding or supporting another architectural member. In CLASSICAL ARCHITECTURE it consists of a base, a shaft, and a CAPITAL. Columns are typically classified by the carving upon their capitals.*

commedia dell'arte (It. "comedy of art") professional, improvised Italian comedy of the 16th and 17th centuries.

commission 1 a work of art ordered by a PATRON. **2** contract to produce work for a patron.

composition the way in which something (e.g. a painting) is visually arranged or put together.

composition board BOARD made of cheap pressed or laminated fibers, used as a painting support in COLLAGE and in sculpture.

conceptual art art that takes the form of mental images, provoked by various stimuli—seen, felt, and heard—and in which the ideas themselves are more important than actual, tangible, works of art.

concrete mixture of sand, stone, and cement; used as a building material, especially in the 20th century.

concrete art term coined in 1930 when Dutch artist Theo Van Doesburg produced a manifesto in Paris entitled *Art Concret*. The term is sometimes used as a synonym for ABSTRACT ART, though the emphasis is not just on GEOMETRIC or ABSTRACT form, but on structure and organization in both design and execution.

constructivism international ABSTRACT ART movement founded in post-revolutionary Russia by Antoine Pevsner and Naum Gabo, whose aims were expressed in the REALISTIC MANIFESTO.

conté crayon a name-brand manufactured chalk.

contrapposto (It. "opposed to," "set against") posing of the human form in painting or sculpture so that the head and shoulders are twisted in a different direction from hips and legs.

conversation piece a type of group PORTRAIT, showing the sitters talking or involved in some other informal activity, that was very popular in 18th-century England.

copper plate copper PLATE on which a design is ETCHED or ENGRAVED; often used as term for the image produced by this method. *See also* DRYPOINT.

copyright an exclusive, legal right to reproduce, publish, and sell material.

Counter-Reformation religious movement in the form of a Catholic revival, which began in direct opposition to the Protestant Reformation sweeping across Europe in the mid-16th century.

cross-hatching DRAWING TECHNIQUE that uses closely spaced parallel lines, intersected (or crossed) by other lines running at an angle, to indicate toned areas.

cubism artistic movement c1907–1915 initiated by Pablo Picasso and Georges Braque as a reaction against IMPRESSIONISM. Cubism aimed to analyze forms in GEOMETRIC terms (ANALYTICAL CUBISM) or reorganize them in various contexts (SYNTHETIC CUBISM); color remained secondary to form. *See also* ORPHISM.

cubofuturism a specifically Russian art movement associated with Kasimir Malevich c1913, which combined elements of CUBISM and FUTURISM.

curvilinear based on a pattern of curved lines; sinuous.

cycle series of paintings linked by a theme, especially used in FRESCO painting.

D

dada international "anti-art" movement originating in Zurich c1916, involving Marcel Duchamp, Jean Arp, Francis Picabia, among others; a forerunner of SURREALISM. Also, **dadaism, dadaist.**

decadent art term that is loosely applied to a group of FIN-DE-SIÈCLE French artists and writers who were inspired by the more morbid expressions of human emotion, and with ESTHETICISM, with which it is synonymous. In England the **decadent movement** was represented by Aubrey Beardsley, Walter Pater, and Oscar Wilde.

decorative esthetically pleasing, ornamental, nonfunctional.

decorative art near synonymous with APPLIED ART, it involves CERAMICS, glass, furniture, textiles, and similar work, but excludes FINE ART.

degenerate art (Ger. *Entartet Kunst*) Nazi propoganda term used from c1937 to describe works of modern art disapproved of by the party. It included works by Wassily Kandinsky and Pablo Picasso.

Delft school 17th-century Dutch GENRE PAINTING associated with Jan Vermeer and Pieter de Hooch.

Der Blaue Reiter *see* BLAUE REITER, DER.

Der Sturm *see* STURM, DER.

De Stijl *see* STIJL, DE.

Deutscher Werkbund (Ger. "German Work League") organization founded in Munich in 1907 to promote good design in machine-made objects.

devotional associated with, or the object of, religious worship.

didactic intending to convey information and teach, as well as giving pleasure or entertaining.

die 1 ENGRAVED stamp for making a coin or MEDAL. **2** hollow MOLD for shaping extruded METAL.

Die Brücke *see* BRÜCKE, DIE.

diptych pair of painted or sculptured panels hinged or joined together; especially popular for DEVOTIONAL pictures in the Middle Ages. *See also* ALTARPIECE.

direct carving method of stone sculpture in which the form is carved immediately out of the block and not transferred from a MODEL.

direct metal sculpture modern TECHNIQUE of METAL sculpture that involves shaping metal by beating it or heating it, instead of by the traditional CASTING technique.

disegno (It. "drawing," "design") during the RENAISSANCE the term acquired a broader meaning of overall concept.

distemper paint based on a glue or size medium, used for painting walls and theatrical scenery.

divisionism analytical painting TECHNIQUE developed systematically by Georges Seurat (1859–91); instead of mixing colors on the PALETTE, each color is applied "pure," in individual BRUSHSTROKES and points, so that from a certain distance the viewer's eye and brain mix the colors "optically." *See also* NEOIMPRESSIONISM, POINTILLISM.

dome (arch.) convex covering set over a circular or polygonal base.

draftsman person who draws or sketches, in particular plans (often of machinery or buildings).

draftsmanship skill in DRAWING or plan-making.

drapery the arrangement of folds of material, painted or sculpted. *See also* STRIATION.

drawing PICTORIAL representation of objects by a TECHNIQUE that is basically LINEAR, using a PEN or PENCIL.

drybrush TECHNIQUE using a dry brush to apply a type of solid paint with a thick consistency. Sometimes used in STENCILING.

drypoint 1 a method of ENGRAVING on METAL, such as copper, with a steel or jeweled point, without using acid. **2** the PRINT thus made. *See also* ENGRAVING.

dynamism the appearance or quality of power, action, and movement. May be used figuratively of inanimate objects such as sculpture. Also, **dynamic**.

E

Early Renaissance *see* RENAISSANCE.

earth colors naturally occurring pigments from the earth, formed of a mixture of iron oxides and clay. Earth colors consist of a range of dull reds, browns, oranges, yellows, and black (known as siennas, OCHERS and umbers).

easel painting (or **easel picture**) small or medium-sized painting executed at an easel. They were usually intended for collectors and connoisseurs, although the term may also be used generally for any portable painting, as opposed to MURAL painting; also called CABINET PICTURE.

Ecole de Paris *see* SCHOOL OF PARIS.

egg tempera *see* TEMPERA.

Eight, The group of New York artists formed in 1907, and later known by this name. The group included Robert Henri. They opposed the restrictive practices of the National Academy of Design, and for their own works turned instead to depicting the contemporary American scene.

elementarism modified form of NEOPLASTICISM introduced by Theo Van Doesburg in the 1920s, which contradicted the ideals of Piet Mondrian by introducing diagonals instead of a rigid horizontal and vertical format.

elevation (arch.) **1** the face or side of a structure. **2** DRAWING or plan of the side of a building.

emboss to MOLD, stamp, or carve a surface to make a design in RELIEF.

emulsion a combination of two non-mixable liquids in which drops of one are suspended in the other. It has not been established when emulsion was first used as a painting MEDIUM, but the TECHNIQUE employed by the 15th-century Flemish painters may have involved the use of an egg/oil emulsion.

enamel 1 vitreous substance (usually lead/potash glass) fused to METAL at high temperature (about 1470°F, or 800°C) and often used for DECORATIVE objects; **2** the object so produced.

enamel paint paint based on thickened linseed oil and RESIN, which dries to a very hard and glossy surface.

encaustic technique ancient TECHNIQUE of painting with WAX and PIGMENTS fused by heat.

engraving 1 the TECHNIQUE of incising lines on wood, or types of METAL such as copper. *See also* MEZZOTINT. **2** the impression made from the engraved block.

Enlightenment 18th-century European philosophical movement that stressed the importance of reason.

en plein air (Fr. "in the open air") used to describe method of painting outdoors, rather than indoors in a studio. It became central to IMPRESSIONISM.

entablature (arch.) upper section of a CLASSICAL arrangement consisting of architraves (lower molding), FRIEZE, and cornice (upper molding).

environmental art art form in which an enclosed "environment" (indoor or outdoor) is created by an artist, with the purpose of surrounding and involving the spectator in a multisensory experience of sound and visual effects.

environmental sculpture a development in contemporary sculpture that is conceived as part of the surroundings in which we live rather than something simply observed by the viewer.

esthetic concerned with the appreciation of what is beautiful and pleasing. Also, **estheticism**.

esthetic movement a late 19th-century artistic movement in England, promoted by Oscar Wilde and American-born artists James Abbott McNeill Whistler, that advocated "ART FOR ART'S SAKE." Its supporters argued that art should be self-sufficient and need serve no DIDACTIC or other purpose.

esthetics philosophy applied to art, which attempts to formulate criteria for the understanding of the ESTHETIC (rather than utilitarian) qualities of art.

etch 1 term used in LITHOGRAPHY for the solution of gum arabic and nitric acid used to render the non-drawn area of a litho stone or PLATE insensitive to grease. **2** (verb) to bite into, e.g. with acid. *See also* BITING.

Etching

The artist (in this case Rembrandt) drew with a fine point directly onto a WAX-*coated* COPPER PLATE, cutting away the wax and exposing the copper. The plate was treated with an acid solution. The acid ate into the copper where the wax had been removed, etching the lines of the drawing into the plate.

The plate was then covered with ink, which sank into the etched lines, and the excess ink was wiped from the surface. An absorbent paper was laid over the plate, and the two were inserted in a press. The paper picked the ink up from the lines to create the etched image; this was a mirror image of the original drawing.

etching 1 process in which a design is drawn on a METAL PLATE through a WAX GROUND; the design is then cut into the plate with acid, and printed. **2** A PRINT that is produced by this method. *See also* SOFT GROUND ETCHING, STOPPING OUT, BITING.*

ethnographic art art inspired by a particular racial culture, especially of a non-Western type. *See also* PRIMITIVE ART.

Euston Road group group of artists working in a broadly naturalistic STYLE in Euston Road, London, for a brief period from 1937 to 1939, including William Coldstream and Victor Pasmore.

expressionism in its widest sense, describes work in which artists are more concerned to express human emotions than to depict reality. More narrowly, the term is applied to work by artists such as Vincent Van Gogh, who used bold lines and dramatic colors to convey their subjective feelings. The term is also used specifically to describe the style that dominated German art from about 1905 to 1930, and that influenced 20th-century artists in other parts of Europe (Egon Schiele in Austria, for example). *See also* ABSTRACT EXPRESSIONISM, BLAUE REITER, DER; BRÜCKE, DIE.

F

façade (arch.) the front (or face) of a building.

facet one side of a many-sided object, e.g. a cut gem.

fantasy a dreamlike, visionary, or grotesque image that is the product of the artist's imagination.

fantastical based on FANTASY, extreme, so as to challenge belief.

fauves (Fr.) originally a derogatory term (Les Fauves) meaning "wild beasts," referring to a group of painters who exhibited at the Salon d'Automne in Paris in 1905, including Matisse. Also, **fauvism, fauvist**.

fête (Fr.) festival, feast; bazaar; SAINT'S day.

fête champêtre (Fr. "outdoor feast") painting of somewhat idealized rural festivities, popular in the 17th and 18th centuries.

fête galante (Fr. "courtship party") an elegant FÊTE CHAMPÊTRE of the type popularized in the 18th century by Antoine Watteau.

fiberglass 1 woven glass fiber fabric. **2** molded PLASTIC containing glass fiber, used for sculpture, furniture, etc.

figural FIGURATIVE, relating to recognizable figures or shapes rather than abstract forms.

figuration 1 form, shape. **2** ornamentation with design. **3** depiction of figures, especially human.

figurative 1 REPRESENTATIONAL. **2** metaphorical, not literal.

figurative art art depicting recognizable figures or objects; synonymous with REPRESENTATIONAL ART.

figurative expressionism art in which figures express extreme emotion, as in the paintings of Francis Bacon, where figures are isolated and terrified.

figure drawing (and **figure painting**) DRAWING or painting in which the human figure predominates, usually full-length.

figurine small MODEL or sculpture of the human figure.

fin de siècle (Fr. "end of the century") late 19th-century style

of ART NOUVEAU, also associated with the SYMBOLIST and DECADENT MOVEMENTS.

fine art art whose value is considered to be ESTHETIC rather than functional, i.e. sculpture, PAINTING and DRAWING, and the GRAPHIC arts. Compare to APPLIED ART and DECORATIVE ART.

fire (verb) to bake in a KILN, especially pottery and PORCELAIN. The process converts "raw" clay to a hard object.

fluorescent (adj.) having the property of absorbing radiation in the invisible, ultraviolet range of the SPECTRUM, and emitting it as visible LIGHT. Fluorescent paint has been used in modern painting for its vivid color and dramatic optical effect.

flying buttress (arch.) a diagonal arch that transmits the thrust of a wall, ceiling, or other structure to an outer support or PILLAR. It was a common feature of GOTHIC architecture. *See also* BUTTRESS.*

folk art NAÏVE art, including FINE ART and DECORATIVE ART, often simple in style and using everyday materials.

foreground in painting or DRAWING, the PLANE nearest the viewer.

foreshortening the use of the laws of PERSPECTIVE in art to make an individual form appear three dimensional.*

form the shape or appearance the artist gives his subject.

formalism the tendency to adhere to conventional forms at the expense of the subject matter.

Flying buttress

A diagonal projecting arch that helps support the weight of a wall or other structure by transferring stress outward and downward to a PILLAR.

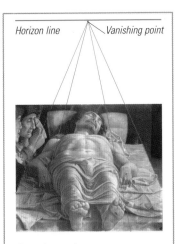

Horizon line Vanishing point

Foreshortening
TECHNIQUE *that shortens and narrows forms, objects, etc., as they recede into the painting toward the* VANISHING POINT. *It is used by artists to suggest three-dimensionality and depth.*

format arrangement, shape, or STYLE, which may be repetitive or stereotyped.

found object an object that is found, not made, by the artist, and is then defined and displayed as a work of art; also known as an *OBJET TROUVÉ* and associated with SURREALISM and DADA.

French chalk finely ground magnesium silicate used with RESIN in LITHOGRAPHY to protect the image from the acid when ETCHING.

fresco (It. fresh) MURAL painting on fresh PLASTER; sometimes called BUON FRESCO ("true fresco") to distinguish it from SECCO PAINTING, painting on dried plaster.*

fresco secco (It. "dry fresco") term that is synonymous with SECCO PAINTING.

frieze 1 part of an ENTABLATURE between the architrave and the cornice, sometimes decorated in RELIEF. **2** horizontal band of decoration along the upper part of a wall or on furniture.

frottage (Fr. "RUBBING") the TECHNIQUE of placing paper over textured objects or surfaces and then rubbing with a WAX crayon or GRAPHITE to produce an image.

functionalism the artistic theory, applied especially in ARCHITECTURE and the DECORATIVE ARTS, that the FORM of a building or object should be determined by its function, and that something that is useful will inevitably be esthetically pleasing.

futurism Italian artistic movement that was founded in 1909 by Filippo Tommaso Marinetti. It exalted the modern world of machinery, speed, and violence.

G

gallery 1 place where works of art are displayed. **2** (arch.) an upper story in a CHURCH above the aisle. **3** a long room, usually extending the full length of the house.

genre STYLE, type.

genre painting type of painting depicting daily life, popularized by 17th-century Dutch painters such as Jan Vermeer.

geometric deriving from a branch of mathematics; in art the use of lines, shapes, points, and space. Also a division of Greek art.

geometric abstraction loose and somewhat inaccurate term for ABSTRACT ART in which the image is composed of nonrepresentational geometric shapes. The term has been used in describing various artists and movements, including the SUPREMATISTS, Piet Mondrian, and Ben Nicholson. *See also* NEOPLASTICISM.

German expressionism *see* EXPRESSIONISM.

gesso (It.) generally used for the mixture of any inert white PIGMENT (such as PLASTER of Paris, chalk, or GYPSUM) with glue; strictly, a mixture in which the inert pigment is calcium sulfate. The mixture was used to cover smooth surfaces such as wood, stone, or canvas, and provide a GROUND for painting. In medieval and Renaissance panel paintings, a coarse gesso, *gesso grosso*, was first applied, followed by several layers of a fine finishing gesso, *gesso sottile*. This produced a reflective white ground.

gestural art a type of GEOMETRIC ABSTRACTION that emphasizes BRUSHWORK and the movements of the artist.

gilding the coating of a surface with GOLD LEAF. Also, **gilded.**

gilt silver or other METAL decorated with GOLD LEAF.

giornata (It. "day") the area of work in MURAL or MOSAIC that could be finished in one day. In FRESCO painting, it refers to the area of INTONACO applied each day. In true fresco (BUON FRESCO), the joins of the *giornate* (plural of *giornata*) are usually visible.

glass fiber *see* FIBERGLASS.

glaze 1 transparent layer of paint applied over another; light passes through and is reflected back, modifying or intensifying the underlayer. **2** vitreous layer made from silica, applied to pottery as decoration or to make it watertight.

glazing 1 process of applying GLAZE. **2** (arch.) window design or construction.

gods and goddesses below are some of the most commonly depicted Greek gods and goddesses in Western art, together with the Roman equivalent (where they exist), and their attributes (symbols of identification):

Apollo the sun god, is usually shown as a beautiful, often naked, young man, crowned with laurel leaves and driving a four-horse chariot. As the god of poetry and music, Apollo is also shown plucking at a lyre (a stringed instrument similar to a harp).

Dionysus (Rom: *Bacchus*) the god of wine, is portrayed as a naked youth, often drunk, and wearing a crown of grapes and vine leaves. Frequently surrounded by a band of attendants, which includes SATYRS, holding pitchers and pipes.

Eros (Rom: *Cupid*) god of love, is most commonly depicted as a winged youth or a chubby infant, carrying bow, arrow, and quiver.

Artemis (Rom: *Diana*) goddess of hunting and PERSONIFICATION of chastity. She carries a bow and quiver, and is shown with hounds pursuing a stag. Also a moon goddess, she is identified by a cresent moon on her forehead.

Hera (Rom: *Juno*) chief goddess of Olympus, wife and sister of *Zeus* (Rom: *Jupiter*), she is known as the protectress of women, marriage and childbirth. Her main attribute is a peacock.

Ares (Rom: *Mars*) brutal and destructive god of war. Ares is generally shown as a young man with helmet, shield, sword, or spear. He fell in love with the goddess of love, *Aphrodite* (Rom: *Venus*).

Hermes (Rom: *Mercury*) messenger of the gods, is shown as an athletic youth. His attributes

Fresco layers
In the TECHNIQUE *of* BUON FRESCO *the artist applied a coat of fine plaster* (ARRICCIO) *over coarse plaster, then drew his design with red-earth* PIGMENT, *or* SINOPIA. *Next he covered the area he intended to paint that day* (GIORNATA) *with a thin layer of smooth plaster* (INTONACO). *He then redrew the design on the wet plaster using pigment mixed with water.*

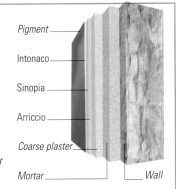

Pigment

Intonaco

Sinopia

Arriccio

Coarse plaster

Mortar Wall

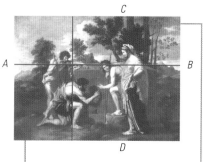

The golden section

A rectangle whose sides are in the golden section can be divided into a square and a rectangle. Here line C–D splits the rectangle of the painting into a square to the left, and a rectangle to the right. Line A–B creates, in the lower left, another rectangle of the same proportion as the original rectangle. This new smaller rectangle can be divided in the same way.

Nicolas Poussin (1594–1665) was a classical artist who used the golden section to plan the composition of many of his works, such as The Arcadian Shepherds *(1638–39), above.*

are winged sandals, a winged hat, and a winged wand, entwined with serpents.

Athena (Rom: *Minerva*) Zeus's daughter, goddess of wisdom, often depicted with an owl and books (symbols of learning). Athena is always dressed in full armor with helmet, shield, and spear, alluding to her other role as defender of just causes.

Poseidon (Rom: *Neptune*) the god who rules the sea is portrayed as an old man with long gray hair and beard. He rides a dolphin or a chariot drawn by sea-horses, and his attribute is a trident (a three-pronged spear).

Aphrodite (Rom: *Venus*) the goddess of love and fertility. Also the mother of Cupid, she is usually shown naked and attended by the Three Graces (three handmaidens, Aglaia, Euphrosyne, and Thalia, personifying grace and beauty). Aphrodite's attributes include a scallop shell, dolphins, a pair of doves or swans, a magic girdle, and a flaming torch or heart.

golden section system of PROPORTION dating from ANTIQUITY and originally thought to have harmonious ESTHETIC qualities. Usually expressed as a straight line divided into two unequal parts; the shorter length bears the same relation to the longer as the longer does to the whole. The system was widely used in artistic composition by artists during the RENAISSANCE.*

gold leaf gold beaten into a thin sheet. *See also* GILDING.

Gothic the last period of medieval art and ARCHITECTURE. Early Gothic usually refers to the period 1140 to 1200; High Gothic c1200–1250; late Gothic from 1250. Mainly characterized as an architectural STYLE, but also by the sculpture, painting, and ornament of the period in which the architecture was built. "Gothic" was used in the RENAISSANCE as an adjective to condemn the "medieval" style.

Gothic Revival architectural and literary movement which began in Britain in the mid-18th century, and which chose to revive the GOTHIC STYLE in a creative and expressive way.

gouache 1 OPAQUE WATERCOLOR paint. **2** a work executed in gouache medium.

graffiti (It. "little scratches") words or drawings scribbled in random fashion on a wall.

grand manner a type of HISTORY PAINTING showing elevated subjects (often biblical, historical, or mythological) in idealized settings, using restrained, but expressive gestures. Raphael and Nicolas Poussin were the best-known exponents of the STYLE, and its principles were made widely known by Joshua Reynolds in his *Discourses on Art* between 1770 and 1771.

Grand Tour an extensive journey abroad, primarily to Italy, but also to France, the Netherlands, Germany, Switzerland, and Austria. Grand tours were fashionable among the English aristocracy in the 18th century, and were considered an essential part of a cultured education.

graphic 1 related to DRAWING or ENGRAVING; **2** vividly descriptive.

graphic art broad term for techniques of illustration on paper, such as DRAWING, ENGRAVING, LITHOGRAPHY, particularly in black-and-white or MONOCHROME.

graphics design or decoration, including PHOTOGRAPHY, associated with TYPOGRAPHIC work and illustration.

graphite crystalline form of carbon, used in PENCILS.

grattage (Fr. "scraping") TECHNIQUE used by 20th-century artists, in which an upper layer of paint is partially scraped away to reveal

the contrasting under-layer.

grazia (It. "grace") term first coined by Vasari in the 16th century to describe a kind of perfect divine beauty present in certain works of art.

grisaille TECHNIQUE of MONOCHROME painting in shades of gray, used as UNDERPAINTING or to imitate the effect of RELIEF.

ground 1 prepared surface on a support to receive paint as, for example, GESSO is used as a ground in early PANEL PAINTING. **2** in ETCHING, the acid-resistant material spread over the METAL PLATE before the design is etched onto the surface. **3** in pottery, the clay that forms the body of a vessel on which a design is executed.

guild medieval form of professional association that regulated standards of craftsmanship and commercial activity.

gypsum chemically, calcium sulfate dihydrate, an inert white material used in making both PLASTER of Paris and cement. Varieties of gypsum include alabaster. *See also* GESSO.

H

halftone the range of tones in a DRAWING, PAINTING, or in a screen pattern, between the darkest and the lightest.

Halftone color printing

To print a picture, the image is first converted into a series of dots of different sizes (halftone) to convey different densities of TONE. *For color printing a separate halftone image is produced for each of the four basic printing colors: cyan, magenta, yellow, and black. When the four colors are printed, the juxtaposition of* *the colored dots combine in the viewer's eye to create the effect of a full-color image.*

 cyan

 magenta

 yellow

 black

halftone process printing process using dots of different sizes to indicate different tones and densities of color, as in newspaper or magazine photographs.*

happening a spontaneous event or display, to an audience, containing theatrical elements; a feature of American and Western European art since the 1960s.

hard-edged painting term coined in 1959 to describe ABSTRACT (but not GEOMETRIC) painting, using large, flat areas of color with precise edges. Also a LINEAR STYLE; the opposite of SFUMATO.

Harlem Renaissance a literary and artistic movement of the 1920s that flourished among black American artists in the Harlem area of New York, and which drew heavily on African IMAGERY and culture for inspiration.

Hellenistic a division of Greek culture and art; the period after Alexander the Great (323 BC) to the late 1st century BC.

hieroglyphics 1 picture writing, as used by the Egyptians. **2** during the RENAISSANCE, a term applied to emblems whose message could be deciphered.

high art art that strives to attain the highest ESTHETIC and moral qualities in both content and expression.

High Baroque *see* BAROQUE.

High Renaissance *see* RENAISSANCE.

high-keyed term applied to paintings that are generally light in TONE and palette (e.g. the work of the IMPRESSIONISTS), as opposed to dark, low-keyed paintings, e.g. those of the CARAVAGGISTI.

history painting painting whose subject and content depict some significant historical event, which

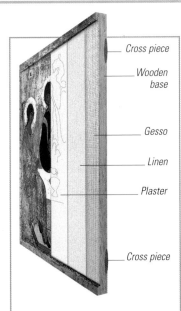

Cross piece
Wooden base
Gesso
Linen
Plaster
Cross piece

Creating an icon
The base for an icon was a piece of non-oily wood, cut to the desired size and with the surface roughened. A layer of GESSO was laid on the rough surface, and a piece of linen placed on top of this. The linen was then covered with a fine PLASTER, which formed the painting surface. The artist used TEMPERA to build up layers of colors. When dry, the painting was given a coating of oil.

is preferably CLASSICAL, actual, or literary. From the 16th to the 19th century, history painting was more highly esteemed than many other forms of painting, especially by the ACADEMIES.

Hudson River school group of American LANDSCAPE painters from c1825 to c1875, who painted romantic scenes of the Hudson River Valley and surrounding areas in New York State. Key figures in the movement were Thomas Cole and Asher B. Durand.

I

icon (Gr. "image," "PORTRAIT") in BYZANTINE, Russian, and Greek Orthodox church art, a representation of Christ or the Virgin, or SAINTS, executed either in MOSAIC or painting; tending to be stereotyped, or in a style following certain fixed types

and methods. Also, **iconic.** *

iconoclasm (Gr. "image-breaking") widespread destruction of religious images, especially in the BYZANTINE Empire, during the 8th and 9th centuries. Also, **iconoclast, iconoclastic.**

iconography the identification of subject matter in works of art; Also, **iconographic.**

iconostasis in Russian or BYZANTINE CHURCHES, the screen on which ICONS are placed.

ideal art art of various periods that is thought to be perfect, and even to improve upon what can be seen in nature. Ideal art is based on the artist's conception rather than his visual perception, e.g. the art of the HIGH RENAISSANCE, or of 17th-century CLASSICISM. Also, **idealized.**

ignudi (It.) nude figures.

illuminated manuscript handwritten book on VELLUM or PARCHMENT, usually medieval, decorated with MINIATURE paintings, borders, and DECORATIVE capital letters. Also, **illumination.**

illusionism the use of optical and perspectival DEVICES to create the illusion of painted objects being three dimensional. Also, **illusionist, illusionistic.**

illusionistic perspective PICTORIAL devices used in a work of art in order to create an illusion of convincing PERSPECTIVE, such as a central VANISHING POINT, ORTHOGONALS, etc.

imagery representation of images or forms in art; putting into paint an artist's mental picture of something.

impasto thickly applied mass of paint or PASTEL, often retaining the original marks made by brush or PALETTE KNIFE. Also, **impasted.**

impressionist *see* IMPRESSIONISM.

impressionism 19th-century French art movement that began in the 1860s and reached its peak in the 1870s–80s. The most important impressionist painters were Claude Monet, Pierre Auguste Renoir, Camille Pissarro, Édouard Manet, Alfred Sisley, Edgar Degas, and Paul Cézanne. They were linked by their common interest in capturing immediate visual impressions, an emphasis on LIGHT and color, and a tendency to paint EN PLEIN AIR (outdoors).

incised line line cut into the surface of an object; used in CERAMICS as a decoration, or in painting on a prepared surface as a guide.

ink painting Japanese and Chinese painting TECHNIQUE, using ink in the same way as WATERCOLOR might be used.

inlay the decoration of furniture, pottery, METALWORK, etc. by inserting patterns of wood, stone, or shell into the body of the object so that the surface remains level. *See also* MOTHER-OF-PEARL.

intaglio decoration produced by cutting into a surface, used in ENGRAVING, ETCHING, gem carving.

international Gothic courtly STYLE in PAINTING, sculpture, and the DECORATIVE ARTS that was prevalent throughout western Europe, particularly France, northern Italy, and the Netherlands from c1375 to c1425. The style balanced the naturalistic and the idealistic, and was characterized by delicate and rich coloring. Principal exponents included Gentile da Fabriano and the Limbourg Brothers.

International Style (arch.) influential style of architecture that originated in the 1920s and 1930s in the work of figures such as Le Corbusier in France, and Mies Van der Rohe and Walter Gropius in Germany. Characteristic of the style were straight-lined forms constructed from glass, steel, and reinforced concrete.

The style spread in the 1930s and 1940s to North and South America, Japan, Britain, and Scandanavia. *See also* BAUHAUS.

intimisme (Fr.) French GENRE PAINTINGS of domestic, intimate interiors, such as the work of Pierre Bonnard and Édouard Vuillard. Also, **intimiste.**

intonaco (It.) the smooth layer of LIME PLASTER that receives the paint in FRESCO painting.

Italianate 1 in an Italian manner. **2** (arch.) showing the influence of Italian RENAISSANCE palace styles, especially in the United States c1840 to 1865.

Italian Primitives artists working in Italy prior to 1400.

J

Jugendstil (Ger. "youth style") German term for ART NOUVEAU.

junk sculpture ASSEMBLAGE sculpture produced since the 1950s using scrap materials and cast-off everyday objects. *See also* NEW REALISM.

K

kiln oven in which pottery is FIRED.

kinetic (adj.) term describing art that moves or has moving parts. It was first used by Russian-born artists Naum Gabo and Antoine Pevsner in the 1920s, but only became commonly used as an artistic term in the 1950s.

kitsch (Ger.) mass-produced everyday objects of the kind manufactured for souvenirs. The word has now become a term for whatever is thought to be in flamboyant bad taste.

L

lacquer a waterproof resinous VARNISH that can be highly polished. True lacquer is obtained from the species of tree *Rhus*

verniciflua, found in China and Japan. Modern commercial "lacquers" are coating materials that dry and harden on a surface. *See also* POLYURETHANE.

landscape 1 PAINTING, DRAWING, or ENGRAVING in which the scenery is the principal subject. **2** scenic areas of a painting or drawing.

lapis lazuli deep blue semi-precious stone from which the PIGMENT ultramarine is extracted.

late Gothic *see* GOTHIC.

lay-in initial stage of traditional oil-painting TECHNIQUE, in which a DRAWING is rendered on the canvas in MONOCHROME to produce a full tonal design, which is then painted over in color. Compare with *ALLA PRIMA.*

Leonardesque in the STYLE of Leonardo da Vinci (1452–1519).

life drawing DRAWING from the live human MODEL.

light in a painting, the source of brightness or illumination; anything that lets in light, e.g. a window.

lime calcium oxide used for making PLASTER and MORTAR.

limner 1 obsolete term for an illuminator of medieval manu-scripts. **2** 16th-century term for a miniaturist or PORTRAIT miniaturist painting in WATERCOLOR. **3** 18th- and 19th-century term for an untutored portraitist. Also, **limning.**

linear (adj.) artistic STYLE that emphasizes lines and contours. Also, **linearity** and **linearism.**

linear perspective method of indicating spatial RECESSION in a picture by placing objects in a series of receding PLANES; parallel lines (ORTHOGONALS) receding from the onlooker's viewpoint appear to meet at a VANISHING POINT.

line engraving 1 the art or process of hand-ENGRAVING in

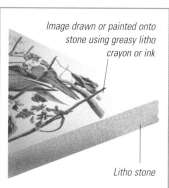

Image drawn or painted onto stone using greasy litho crayon or ink

Litho stone

Lithography
The process of lithography is based on the principle that water and grease do not mix. An image is drawn on the stone with a grease-based drawing material, such as a lithographic crayon or ink. The surface of the stone is then chemically treated with a mixture of gum arabic and dilute nitric acid. When the stone is dampened and the printing ink is applied by a roller, the non-image areas repel the ink and retain water, while the image areas accept the ink and repel the water. To make a PRINT, *paper is placed on top of the inked stone and a litho press used to transfer the image to the paper.*

INTAGLIO and COPPER PLATE, using a burin, the engraver's chief tool. **2** a PRINT taken from such a plate.

linocut Method of producing a PRINT from a design carved into a block of linoleum. *See also* WOODCUT.

lithography printing method in which a design is drawn on stone or a METAL PLATE with a greasy crayon or paint, and then inked. Also, **lithographic.** *See also* OFFSET LITHO.*

London group group of English artists who were influenced by POSTIMPRESSIONISM, and who exhibited together from 1913. They were an association of the CAMDEN TOWN GROUP with other smaller groups of artists.

lost wax *see* CIRE PERDUE.*

low life tavern or drinking scenes, etc. depicted in GENRE painting.

low relief *see* RELIEF.

luminosity the appearance of reflecting light, or ability to do so.

lyrical abstraction term coined in 1947 by French painter Georges Mathieu to describe the more DECORATIVE STYLE of *L'Art Informel* and ABSTRACT EXPRESSIONISM.

lyricism an intensely poetic, decorative quality.

M

Maestà (It. "majesty") a representation of the Madonna (Virgin Mary) and Child, in which the Madonna is seated on a throne and surrounded by a host of angels and SAINTS.

magic realism term coined by German critic Franz Roh in 1925. He used it to describe artworks exhibiting sharp-focus detail as seen in the paintings of exponents of the NEUE SACHLICHKEIT.

maniera (It. "style," "manner") according to the writings of Giorgio Vasari (1511–1574), the stylishness associated with the art of 16th-century Italy. *Bella maniera* (It. "beautiful style") was considered the highest artistic expression of the age, epitomized in the work of Raphael and Michelangelo Buonarroti.

mannered the exaggerated characteristics of any STYLE. Before the 1930s the term was often synonymous with Italian MANNERISM.

mannerism artistic STYLE originating in Italy c1520–90 (between HIGH RENAISSANCE and BAROQUE) tending to employ distorted poses, elongated human figures, artificial and brash color, and a highly charged emotional content. Also, **mannerist, mannered.**

manuscript. *See* ILLUMINATED MANUSCRIPT.

marble type of limestone used since ANTIQUITY for sculpture and building. It occurs in various colors, from pure white to black, and is often veined. Sometimes used in small pieces to form a MOSAIC or INLAY.

marbling DECORATIVE effect produced by staining or painting in streaks to resemble MARBLE.

marine painting or DRAWING of a sea subject.

master in the medieval GUILD system, one who was sufficiently skilled as to be able to practice his art on his own.

masterpiece originally the name given to a test piece of work done by the medieval apprentice in order to qualify as a MASTER of his GUILD. The term is now used more freely to mean an artist's work of outstanding importance or quality.

matt (adj.) non-reflective; smooth but not shiny.

medal small commemorative PLAQUE or award, usually made from metal.

medallion 1 large MEDAL, usually bearing a PORTRAIT. **2** prominent oval or circular MOTIF. **3** the central motif (of any shape) of a carpet.

medium 1 the means through which an artist expresses him- or herself, e.g. painting, sculpture, etc. **2** the materials that an artist uses, e.g. in sculpture: metal, marble, etc. **3** the substance with which PIGMENT is mixed and thinned to make PAINT, e.g. egg yolk to produce egg TEMPERA, linseed oil to produce OIL paint, etc.

metal 1 solid crystalline substance, usually opaque, ductile, dense, e.g. gold, silver, copper, iron. Also, **metalwork**. **2** molten glass, in glassmaking process.

metamorphic having, or suggesting, the ability to change shape.

Metaphysical Painting (It. *Pittura Metafisica*) style of painting c1911–1920 practiced by artists such as Giorgio de Chirico and Carlo Carrà in which weird, dreamlike images were juxtaposed with ordinary objects, and set in dramatically receding perspectives. The style greatly influenced the surrealists. *See also* SURREALISM.

mezzotint 1 method of copper ENGRAVING. **2** PRINT produced by this method.

Middle Ages in European history, the period between the end of CLASSICAL ANTIQUITY and the end of the RENAISSANCE (5th–15th century AD).

miniature very small piece of work, such as the illustration in a medieval ILLUMINATED MANUSCRIPT. During the RENAISSANCE and the 18th and 19th centuries, the term was more specifically applied to small portraits painted on ivory.

minimal art modern art that rejects subject, texture, atmosphere, etc., and reduces forms and color to extreme simplicity. Also, **minimalism, minimalist**. *See also* POST-PAINTERLY ABSTRACTION.

mixed media the combination of different materials in the same work in modern art, sometimes including PERFORMANCE ART.

mobile KINETIC sculpture, probably first produced by Alexander Calder, and so-named by Marcel Duchamp in 1932. The sculpture is hung from wires so that it is moved by air currents.

model 1 in art, person who poses for drawing, sculpture, etc. **2** preliminary study in clay, wax, etc. **3** (verb) to shape in three dimensions, e.g. in clay.

model book PATTERN BOOK used for reference as a source of MOTIFS by artists in the Middle Ages. The book usually contained highly finished drawings of natural forms (plants, animals, DECORATIVE motifs, etc.) intended for copying into paintings.

modeling 1 three-dimensional representation of objects. **2** the artist's depiction, or grasp, of solid form.

modello (It. "model") preliminary SKETCH, either drawn or painted. Sometimes quite elaborate, and occasionally prepared for a competition for patronage, or a COMMISSION.

modern art art of the late 19th and 20th century that rejects past styles and reflects its own times. Modern art encompasses a wide range of artistic theories, movements, and styles.

modern moral type of moral narrative painting portraying satirical scenes of 18th-century English life, with each picture showing a different episode of a story in an uncompromising and somewhat theatrical manner. Made famous by William Hogarth in series such as *A Rake's Progress* (c1735).

Modern Movement name derived from Nikolaus Pevsner's book *Pioneers of the Modern Movement* (1936) that describes the ARCHITECTURE and design of the 1920s and 1930s with its clean, simple lines and its emphasis on FUNCTIONALISM.

mold shape or pattern in which a CAST image is reproduced. Also, **molded,** to **mold** (verb).

molding a shaped strip of stone or wood, plain or decorated, used to ornament a wall or piece of furniture.

monochrome (noun) picture produced in various tones of one color only, especially black. (adj) in or resembling monochrome. Also, **monochromatic.**

monumental 1 connected with, or serving as, a monument. **2** used figuratively of paintings and other art forms to mean imposing or massive.

mortar (noun) building material made from cement and/or LIME combined with sand and water. The mixture is usually used as a bond or covering for stone or brick. Also to **mortar** (verb): to join or cover stones or bricks.

mosaic design formed from small pieces of stone, glass, MARBLE, etc. (known as "tesserae"), set into MORTAR or an adhesive.

mother-of-pearl hard, pearly substance forming inner layer of mollusc shells. Used in DECORATIVE METALWORK, jewelry, and as INLAY.

motif a repeated distinctive feature in a design. *See also* QUATREFOIL.

multiple art produced since the 1960s, theoretically made in unlimited numbers ("multiples") as consumer articles; the opposite of the traditional "limited edition." *See also* POP ART.

Munich Sezession withdrawal in 1892 of German artists in Munich from the traditional art institutions. It remained relatively conservative and was followed by the VIENNA SEZESSION (1897), and the BERLINER SEZESSION (1908). *See also* SEZESSION.

mural picture painted on a wall or ceiling.

muse 1 in Greek and Roman mythology, nine sister goddesses who inspired poetry, music, the arts, and sciences, and are identified in painting by their various attributes, or symbols. **2** a source of inspiration.

mythological painting painting of subjects chosen from CLASSICAL mythology, popular from the 15th to the 19th centuries, e.g. *Spring* (c1478) by Sandro Botticelli.

N

Nabis, Les (from the Hebrew, *nabhi*, "prophets") group of French artists working from c1892 to 1899, influenced by Paul Gauguin in their expressive use of flat color and exotic DECORATIVE effects. They included Paul Sérusier, Pierre Bonnard, Jean-Édouard Vuillard, and Félix Vallotton. They are linked also to the SYMBOLISTS.

naïve the work, STYLE, or art of untaught artists, usually unsophisticated or childlike in their approach. Henri Rousseau and Grandma Moses were two of the main exponents of naïve art.

naturalism accurate, detailed representation of objects or scenes as they appear, whether attractive or otherwise. The term was first used of the 17th-century CARAVAGGISM. *See also* REALISM.

nave (arch.) main body or aisle of a CHURCH.

Nazarenes group of German painters, including Johann Friedrich Overbeck, who worked in Rome in the early 19th century. Inspired by northern and Italian art of the 15th and early 16th centuries, their work influenced, among other artists, the PRE-RAPHAELITE BROTHERHOOD.

neoclassicism the late 18th-century European STYLE, lasting from c1770 to 1830, which revived the ANTIQUE, reacting against the worst excesses of the BAROQUE and ROCOCO. It implies a return to CLASSICAL sources, and imposed restraint and simplicity on painting and ARCHITECTURE. *See also* RETURN TO ORDER.

neo-Gothic revival of the GOTHIC STYLE in 18th-century England, especially in ARCHITECTURE.

neoimpressionism movement developed from 1886 by artists including Georges Seurat. Like impressionism, it was concerned with light and color, but it involved a more scientific analysis of color and a more formal approach to composition. *See also* DIVISIONISM; POINTILLISM.

neoplasticism synonymous with DE STIJL. The term was coined by Piet Mondrian to describe his type of GEOMETRIC ABSTRACTION, which was restricted to non-representational horizontal and vertical forms, PRIMARY COLORS, black, and white.

neoprimitivism early 20th-century movement in Russian painting that combined aspects from Russian folk art (in particular its popular WOODCUT prints, known as *lubki*), with influences from CUBISM, EXPRESSIONISM, and FAUVISM. Its main exponents were Natalia Goncharova and Mikhail Larionov; Marc Chagall was also influenced by the movement. *See also* PRIMITIVE ART.

neo-Romanticism broad term for several 20th-century European art movements that draw on mystical, dreamlike subjects, expressive, emotional forms, and SURREALISM.

Netherlandish school general term referring to 15th-century artists from countries such as the Netherlands, and Flanders (i.e. north of the Alps), who painted in the northern tradition; as in the STYLE of such artists as Jan Van Eyck and Rogier Van der Weyden.

Neue Künstlervereinigung (Ger. "New Artists' Association") A group of artists founded in Munich in 1909 with Wassily Kandinsky as president, and influenced by the Munich JUGENDSTIL and FAUVISM. Kandinsky and Franz Marc later formed the BLAUE REITER group.

Neue Sachlichkeit (Ger. "New Objectivity") term coined by Gustav Hartlaub in 1925 for the movement in German painting of the 1920s and 1930s that reflected widespread postwar cynicism. Otto Dix and George Grosz were leading figures in the movement. *See also* EXPRESSIONISM.

Neue Sezession a group of artists in Germany that, in 1910, under the leadership of Max Pechstein, broke away from Max Liebermann's BERLINER SEZESSION to promote more AVANT-GARDE art.

New Bauhaus short-lived school of design founded in Chicago under the directorship of László Moholy-Nagy between 1937 and 1938; he founded the Chicago Institute of Design one year later.

New Objectivity *see* NEUE SACHLICHKEIT.

New Realism (or *Nouveau Realisme)* term coined in 1960 by French art critic Pierre Restany to describe art derived partly from DADA and SURREALISM that used industrial and everyday objects to make JUNK SCULPTURE.

New York school the core of ABSTRACT EXPRESSIONISM in New York in the 1940s and early 1950s. Members of the group included Willem de Kooning, Jackson Pollock, and Mark Rothko.

niche (arch.) recess in a wall, often containing a STATUE.

nimbus halo or light depicted around a sacred image.

nocturne night scene.

nonrealistic in art, that which does not resemble nature or real life.

northern Renaissance non-Italian Western art of the Renaissance period (c1420–c1600).

Nouvelle Tendance (Fr. "New Trend") short-lived international KINETIC art movement of the 1960s.

O

objet trouvé (Fr.) *see* FOUND OBJECT.

ocher (or ochre) natural earth of silica and clay, colored by iron oxide. It may be yellow, red, or brown, and is used as a PIGMENT.

oeuvre (Fr. "work") **1** the total output of an artist. **2** a work of art.

offset litho LITHOGRAPHIC TECHNIQUE in which ink is transferred from a PLATE to a rubber roller, and then to paper, as opposed to direct from plate to paper.

oil viscous liquid of vegetable or mineral origin, used as a MEDIUM in painting and printing. "Oils" is often used as shorthand for **oil painting**.

oil sketch *see* SKETCH.

Old Masters European paintings or painters from the period 1500 to 1800.

opaque impermeable to light; not TRANSPARENT or TRANSLUCENT.

op art abbreviation of "optical art." Abstract art movement of the 1960s in which the precise use of GEOMETRIC shapes, tones, lines, and colors produce optical illusions, and paintings appear to shimmer or pulsate. Leading exponents include Bridget Riley and Victor Vaserely.

organic in art, resembling, related to, or produced from a living organism.

ornament decoration or DECORATIVE object. Also, **ornamented**.

Orphism term coined in France c1912 by poet and art critic Guillaume Apollinaire to describe the branch of CUBISM associated with artists such as Robert Delaunay and Marcel Duchamp, who sought to place a greater emphasis on color and lyricism in their work than Cubists such as Pablo Picasso and Georges Braque. The term was derived from the name of the mythological Greek lyre-player and poet, Orpheus. Also known as **Orphic cubism**.

Perspective *is the means of representing three dimensions on a two-dimensional surface. Parallel lines known as* ORTHOGONALS *appear to converge to a* VANISHING POINT (VP) *on the horizon line. The horizon line is always the same as the viewer's eye level. 1) One-point perspective: all receding lines appear to converge at the same point on the horizon line. 2) Two-point perspective: the cubes are at an angle to the picture* PLANE. *There are two vanishing points, lying equidistant from the center on the horizon line. 3) Three-point perspective: the cubes are at an angle to the picture plane and also tilted upward, so there is a third vanishing point above.*

Two-point perspective

One-point perspective

Three-point perspective

VP · VP · VP · VP · VP

Eye level · Eye level · Eye level · Eye level

orthogonal in LINEAR PERSPECTIVE, an orthogonal is a line apparently at right angles to the PICTURE PLANE, which appears to recede to the VANISHING POINT. *See also* PERSPECTIVE.

P

paint PIGMENT dispersed in a MEDIUM.

painterly a term coined in 1915 by the art historian Heinrich Wölfflin to describe one of two contrasting styles in painting: LINEAR, which emphasizes contours; and painterly, which emphasizes color and TONE. Also, **painterliness.**

painting 1 in art, the process of applying paint to a flat surface such as a wall or canvas to produce an artistic work. **2** the artistic work produced in this way.

palette 1 piece of wood, METAL, or glass on which an artist mixes PAINT. **2** figuratively, the range of colors used by the artist.

palette knife flexible, spatula-shaped knife for mixing or applying thick-bodied PAINT.

panel 1 flat piece of wood or metal used as a painting support, as distinct from a canvas. **2** distinct area or compartment as part of a design, as on an ALTARPIECE.

panel painting painting on a wood or metal panel.

panorama painting of a view or LANDSCAPE; especially large-scale painting around a room, or rolled on a cylinder.

pantograph an instrument for copying maps or DRAWINGS to a different scale.

papier-collé (Fr. "pasted paper") COLLAGE of paper and card, a technique first used by Georges Braque, c1912.

papier-découpé (Fr. "cut-up paper") an arrangement of shapes cut from colored paper and stuck down. The technique was used by Henri Matisse in his later works, produced in the early 1950s.

papier-mâché (Fr. "chewed paper") paper pulped with glue and then molded, sometimes to a frame, baked, and polished.

parchment animal skin from calf, sheep, lamb, goat, or kid, used for writing, painting, and bookbinding.

pastel stick of PIGMENT mixed with gum, or work executed in this MEDIUM. Because pastel tends to be light and chalky in TONE, the word is also used to describe pale, light colors.

pastellist artist working in PASTEL.

pastiche 1 work in the STYLE of another artist. **2** (derogatory) work made from fragments of another work or works.

pastoral idealized LANDSCAPE painting or country scene. *See also* ARCADIA.

patron someone who patronizes or supports the arts and artists. Also, **patronage.**

patron saint a SAINT regarded as the guardian of a particular group or country, e.g. Saint Christopher is the patron saint of travelers. *See also* SAINTS.

pattern book book of MOTIFS and designs used as a reference book by artists and industrial designers. *See also* MODEL BOOK.

pen DRAWING instrument used with ink, sometimes made of a quill (the bare shaft of a feather).

pencil DRAWING instrument of graphite or similar substance; in the MIDDLE AGES the term also meant a brush.

pensieri (It. "thoughts") in sculpture, small MODELS made as preliminaries to larger models.

performance art an event containing aspects of drama, visual art, and music, which is performed as an art form. It is

closely related to a HAPPENING, but is more rehearsed, and does not require audience participation.

personification the giving of human characteristics to abstract or inanimate things, e.g. green-eyed jealousy; Old Father Time. *See also* GODS AND GODDESSES.

perspective method of representing objects on a two-dimensional surface so that they appear three-dimensional. *See also* LINEAR PERSPECTIVE, AERIAL PERSPECTIVE.*

photography method of producing an image by the chemical action of radiation, such as light, on a sensitive film.

photomontage picture combining juxtaposed photographic images.

Pietà *(1497–1500) by Michelangelo Buonarroti.*

pictogram (or **pictograph**) PICTORIAL SYMBOL, especially in PRIMITIVE ART.

pictorial illustrative, or expressed in pictures. Also, **pictorialism.**

picture plane the surface area of a painting, also called the picture field.

picturesque quaint, charming. From the 18th century onwards "the picturesque" acquired a more specific meaning, particularly in connection with LANDSCAPE painting, landscape gardening, and ARCHITECTURE; it suggested a deliberate roughness or rusticity of design, and was to some extent transitional between CLASSICISM and ROMANTICISM.

Pietà (It. "pity," "piety") representation of the Virgin Mary holding the dead body of Christ.*

pigment a colored solid, usually dispersed in a MEDIUM to form PAINT. *See also* OCHER.

pilaster (arch.) rectangular attached COLUMN that projects from a wall by less than one-third of its width.

pillar (arch.) free-standing vertical supporting member; unlike a COLUMN it may be square.

Pittura Metafisica *see* Metaphysical Painting.

plane in art, a predominantly flat surface.

plaque DECORATIVE or commemorative RELIEF in PLASTER, PORCELAIN, or METAL. *See also* MEDAL.

plaquette small metal PLAQUE, usually cast by the *CIRE PERDUE* method and popular from the 14th to 16th centuries.

plaster material used for surfacing walls, usually interior. It is made by mixing various dry materials, including clay, LIME, and GYPSUM, with water, applying it to

the wall, and allowing it to set; *See also* FRESCO, MORTAR. PLASTER of Paris is calcium sulfate hemihydrate; it is often used for making MOLDS.

plastic 1 synthetic polymer that can be MOLDED by heat and pressure. **2** describes anything molded or modeled. **3** often also used of the three-dimensional values of a painting.

plate 1 in printing and ENGRAVING, a sheet of glass, METAL, rubber, etc, that has a printing surface produced by a process such as ETCHING. **2** the print made from such a sheet. **3** in PHOTOGRAPHY, a sheet of glass or metal covered with light-sensitive coating.

plating layer of thin METAL applied to an object, or the application of this layer.

plein air *see EN PLEIN AIR.*

Plexiglas (U.S. trademark) ACRYLIC sheeting used in modern sculpture (also known as perspex). Transparent Plexiglas is often used in picture framing.

plywood thin BOARD composed of several layers of wood glued together with the grain crossed to give strength.

pointillism (Fr.) a NEOIMPRESSIONIST TECHNIQUE pioneered by French artist Georges Seurat, in which small dots of pure color were applied next to each other on the canvas so that from a certain distance they would appear to mix "optically," instead of being mixed on a palette. Also, **pointille,**

pointillist. *See also* DIVISIONISM, NEOIMPRESSIONISM.

polychrome painted in several colors; usually refers to sculpture. Also, **polychromy.**

polymorphic painting "multiform" painting, produced by some KINETIC artists. The appearance of the work changes according to the position of the observer.

polyptych painted work (usually an ALTARPIECE) of more than three panels. *See also* DIPTYCH, TRIPTYCH.

polyurethane synthetic RESIN based on ethyl carbonate, used to make VARNISHES and LACQUERS.

pop art art derived from the consumer and popular culture of the 1960s, featuring packaging, comic strips, and advertising images. Pop art rejected the notion of craftsmanship; many of its practitioners used commercial techniques to mass-produce their art in MULTIPLES.

porcelain hard, refined CERAMIC material, invented by the Chinese in the 17th century. *See also* SOAPSTONE.

porphyry hard volcanic stone used since ANTIQUITY for sculpture.

portico (It.) covered COLONNADE at the entrance to a building.

portrait a drawn or painted image of a person, usually one that is naturalistic and identifiable. Also, **portraiture, portraitist.** *See also* CARICATURE; CONVERSATION PIECE; ICON; LIMNER; SELF-PORTRAIT; SILHOUETTE.

pose the stance or attitude of the human figure, or group of figures, in a painting or sculpture.

poster public advertisement, developed as an art form from the 19th century onward.

postimpressionism term coined by the art theorist Roger Fry for the styles that followed after, and reacted against, IMPRESSIONISM. The central figures are Paul Cézanne, Vincent Van Gogh, and Paul Gauguin. *See also* LONDON GROUP; SYNTHESISM; VINGT, LES.

post-painterly abstraction term coined by the American critic Clement Greenberg for the work of a group of ABSTRACT artists of the 1960s. It includes a number of specific styles and movements, such as COLOR-FIELD PAINTING and MINIMAL ART.

precisionism STYLE of American painting that flourished in the 1920s using industrial and urban scenes as its subject matter. The works are CUBIST-inspired, with simplified GEOMETRIC shapes, and bold, smoothly painted colors. The best-known exponents were Charles Demuth, Georgia O'Keeffe, and Charles Sheeler.

pre-Columbian American art and culture before 1492.

predella **1** a platform on which an altar stands. **2** lower part of a painted ALTARPIECE.

prehistoric art art of the Stone Age, which

Primary colors and the color wheel
The three PRIMARY COLORS are red, yellow, and blue. When any two of these are mixed together they form secondary colors. Increasing the amount of one primary color gives a further, "tertiary" shade: red and yellow produces orange, for example; and the addition of more red produces orange-red. Complementary colors are color opposites, forming strong contrasts, and lie directly opposite each other on the color wheel. The complementary color to one of the primary colors is a mixture of the other two, so green is the complementary to orange. Secondary and tertiary shades also have their complementaries.

may be divided into paleolithic, mesolithic, and neolithic periods. *See also* PRIMITIVE ART.

Pre-Raphaelite Brotherhood English association of artists, c1848–1954, including Dante Gabriel Rossetti, William Holman Hunt, and Edward Millais. They shared a desire to breathe new life into artistic traditions, and an admiration of Italian art "pre-Raphael," i.e., before the HIGH RENAISSANCE. They were inspired by the sincerity of such art, using it as a guide for studying nature directly, and for creating images with a genuine moral content.

primary colors red, blue, and yellow; the colors that can be mixed to produce all other colors, but that cannot themselves be produced from mixtures.*

primitive art 1 art of a prehistoric culture. *See* PREHISTORIC ART. **2** early European, non-naturalistic art. **3** untrained, NAÏVE art. **4** ETHNOGRAPHIC ART (a 19th-century usage) in which artists "borrow" images or styles from prehistoric or nonindustrial cultures for use in their own work, e.g. Paul Gauguin and Henry Moore. Also, **primitivism.**

print 1 any image, pattern, or lettering produced on fabric or paper by a variety of GRAPHIC processes. **2** (verb) to make an impression or image by such a process. **Printmaking** involves producing such an image that is also esthetically pleasing, or illustrative.

Prix de Rome an art scholarship founded in 1666 by the French Academy in Rome. Prize-winning students could spend four years studying in Rome. The prize was highly sought after during the 18th and 19th centuries; it is still in existence today.

process art modern works of art in which the process of creation itself becomes the subject of the work.

profile 1 DRAWING, outline, or SILHOUETTE of a figure, especially the human figure viewed from the side. **2** (arch.) section of a MOLDING. **3** cross-section of any structure.

proportion ratio or relationship of dimensions. *See also* GOLDEN SECTION, SECTION D'OR.

pulpit raised platform from which a sermon is delivered in CHURCH.

pumice light volcanic stone consisting of silicates of sodium, aluminium, and potassium; used as an abrasive, and for polishing.

purism movement founded in 1918 by Le Corbusier and Amédée Ozenfant that aimed to purify CUBISM of any DECORATIVE elements, emphasizing pure outline and impersonality. It was mainly influential on ARCHITECTURE and design.

putto (It. "little boy," pl. *putti*) figure of a chubby, naked boy in painting or sculpture, frequently represented in RENAISSANCE art, sometimes as a winged cherub; putti have their origins in CLASSICAL ANTIQUITY.

Q

quatrefoil 1 (arch.) four-arc opening in GOTHIC TRACERY. **2** four-lobed decorative MOTIF, similar in appearance to a clover leaf.

Quattrocento (It.) 15th century.

R

rayonism development of ABSTRACT ART by the Russian artists Mikhail Larionov and Natalia Goncharova, c1913, which was an offshoot of CUBISM, and in some ways the forerunner of FUTURISM.

readymade name given by the DADA artist Marcel Duchamp to prefabricated objects exhibited as works of art.

realism 1 in art, similar to NATURALISM in attempting to convey

subjects accurately; the opposite of ABSTRACTION; also, **realist. 2** a STYLE of painting dating from the 19th century, typified by Gustave Courbet, that deliberately depicts everyday subject matter.

Realist Manifesto manifesto produced in 1920 by Russian-born brothers Naum Gabo and Antoine Pevsner that encouraged artists to "construct" art. Their aim was to create geometric, abstract art using modern materials such as plastic. The CONSTRUCTIVISM movement took its name from the manifesto's directive.

recession in painting, the illustration of depth or distance achieved through the use of color or PERSPECTIVE.

reductivist minimalist. *See also* MINIMAL ART.

Regency style the STYLE of English art c1811–1830, i.e. during the regency and reign of King George IV.

regionalism STYLE of American painting of the 1930s and 1940s that portrayed the lifestyle and characteristics of a certain, often rural or midwestern, area of the country.

relief sculpture, carving, etc., in which forms project from a background PLANE and depth is hollowed out of that plane; the type of relief is determined by the degree to which the design stands out; thus *alto rilievo* (It. "high relief") and *basso rilievo* (It.) ("low relief") or *bas relief* (Fr.), in which the projection is slight.

relief process any GRAPHIC process in which the areas not to be seen are cut away, so that the design stands out in RELIEF on the block; the term is applied to WOODCUTS, LINOCUTS, etc.

Renaissance (Fr. "rebirth") the period of Italian art from c1400 to 1520, characterized by increased emphasis on accurate depiction

of the natural world, and the rediscovery of CLASSICAL art. The **Early Renaissance** is deemed to be between c1420 and 1500; **High Renaissance** refers to the period of the finest achievements of Leonardo da Vinci, Raphael, and Michelangelo Buonarroti, c1500–1520.

representational art art that attempts to show objects as they really appear, or at least in some easily recognizable form. Synonymous with FIGURATIVE ART.

resin 1 natural organic compound secreted by some plants and insects, used in VARNISHES, LACQUERS, and PAINTS. **2** synthetic substance formulated to resemble natural resin, such as POLYURETHANE.

return to order a brief CLASSICAL revival of the 1920s and 1930s among AVANT-GARDE artists, mainly in Mediterranean countries, which sought a return to restraint and traditional themes in art. Pablo Picasso, for example, consciously recalled images from ANTIQUITY; timeless ARCADIAN scenes with fauns, SATYRS, and other creatures drawn from mythology. Also known as NEOCLASSICISM, and "the classical revival."

rococo elegant DECORATIVE STYLE of art and ARCHITECTURE of c1730 to 1780 that developed in France and rapidly spread throughout Europe. It is characterized by a feeling of lightness and richly ornamented surfaces, making wide use of SCROLL and plant MOTIFS. The word is thought to derive from the French word *rocaille*, meaning decorative shellwork.

Romanesque (arch.) STYLE of art and ARCHITECTURE that lasted from 1000 to 1150 in France, and to the 13th century in the rest of Europe. Romanesque architecture is characterized by massive vaults, and rounded arches; in painting and sculpture the tendency is towards strong STYLIZATION, with little attempt at conveying NATURALISM.

Romantic *see* ROMANTICISM.

Romanticism in the late 18th- and early 19th-century, the opposite of CLASSICISM; the imagination of the artist and the choice of literary themes predominated. Leading Romantic painters included Eugène Delacroix and J. M. W. Turner.

rotunda (arch.) round building or internal room surmounted by a DOME.

roughcast rough preparation of sand and LIME applied to a wall prior to the smooth PLASTER.

roundel circular panel, painting, MEDALLION, or ornamental STAINED-GLASS window.

rubbing *see* FROTTAGE.

S

sacra conversazione (It. "holy conversation") in Christian ICONOGRAPHY, the image of the Virgin and Child with SAINTS, as a group PORTRAIT.

saints listed below are the most commonly depicted saints in Western art, together with their various saintly attributes (a piece of property, a quality, or a feature that belongs to or represents them):
Saint Augustine Christian saint and theologian. He is portrayed as middle-aged, in a bishop or monk's habit; his attribute is a flaming heart, symbolic of his fervent religious belief.
Saint Christopher formerly a Christian saint and martyr, and the PATRON SAINT of travelers. He is shown carrying the infant Christ across a river on his shoulders, using a palm tree for a staff.
Saint Francis founder of the Franciscan Order, and a deeply pious man. He wears a monk's habit with three knots in the tie to represent the vows of poverty, chastity, and obedience.
Saint George a legendary warrior saint and martyr, he is depicted clad in armor, fighting a dragon, which symbolizes evil. He is the PATRON SAINT of England.
Saint Jerome one of the four Fathers of the Church. His most common attributes are a lion and a cardinal's hat. He is shown as **1** penitent in the desert, kneeling with a crucifix, with a skull and hour-glass nearby. **2** in his study at his desk with his books. **3** as a doctor of the Church in cardinal's robes, holding a model of the Church.
Saint John the Baptist Christ's messenger is most commonly portrayed dressed in an animal-skin tunic, carrying a reed cross. His life came to a gruesome end: he was beheaded and his head was brought in on a plate to Salome at the banquet of Herod.
Saint Paul an apostle, often paired with *Saint Peter* as a cofounder of the Church. His attributes are a book or SCROLL and a sword.
Saint Peter the leader of the Twelve Apostles, shown as an old man with short, curly hair and beard, and dressed in a yellow cloak over a blue or green tunic. His main attribute is a key, which symbolizes the gates of Heaven or Hell. Other attributes are an upturned cross, a crozier, a book, and a rooster.
Saint Sebastian Christian saint and martyr. He is shown at his martyrdom, tied to a PILLAR, dressed only in a loincloth, and pierced by arrows.
Saint Stephen first Christian martyr, who was stoned to death. His martyrdom is most commonly depicted, and the stones are his principal attribute.

salon (Fr.) large room.

Salon French annual exhibition (held from 17th century onward) of painting and sculpture by members of the ACADEMY; traditionally hostile to innovation.

Salon des Indépendants founded in 1884 in France, the Société des Artistes Indépendants included the artists Georges Seurat and Paul Signac. The society was set up in opposition to the official Salon and existed until World War I.

Salon des Réfusés exhibition of 1863 promoted by Napoleon III to show works rejected by the Paris SALON. Among those who exhibited were Édouard Manet, Paul Cézanne, Camille Pissarro, and James Abbot McNeill Whistler. The Salon des Réfusés marked an important turning point in art: after its show, other artists began to exhibit independently, e.g. the IMPRESSIONISTS in 1874.

salon painting the STYLE acceptable to the Paris SALON, implied to be dull and stereotyped.

sarcophagus a stone coffin, often decorated, especially common in ANTIQUITY.

satin silky fabric with a glossy surface.

satyr mythological attendant of the Greek god Dionysus (Rom: Bacchus); usually depicted in painting as half man, half goat, with horns and tail, or with the feet, ears, and tail of a horse. *See also* GODS AND GODDESSES.

schematic representing objects by symbols or diagrams. Also, **schematized**.

School of Paris (Ecole de Paris) **1** broad name for various modern art movements originating in Paris, including Nabism (*see* NABIS, LES), FAUVISM, CUBISM, and SURREALISM. **2** school of medieval MANUSCRIPT ILLUMINATORS in Paris from the mid-13th to 15th centuries.

School of Pont-Aven not a true "school" but the group of painters, generally SYMBOLISTS, who worked at Pont-Aven, France, during the 19th century, including LES NABIS, and Paul Gauguin.

scroll 1 architectural ornament similar in form to a scroll of PARCHMENT. **2** scroll of paper or silk, popular in Oriental art, usually painted in ink or WATERCOLOR. *See also* CARTELLINO.

scumble an OPAQUE, or semi-opaque, layer of paint applied over another so that the first is partially obliterated, producing a slight broken (cracked) effect.

scuola (It. pl. *scuole*) a school or confraternity of artists working under the same influence or MASTER.

seal ENGRAVED gem or METAL stamp used to make an impression in WAX or similar on a document, and designed to serve as a signature; the impression so produced.

seascape PAINTING or DRAWING of the sea and shipping.

secco painting (It. *secco*, "dry") method of wall painting onto dry PLASTER, using PIGMENTS in LIME water, or an egg MEDIUM. Often used for retouching FRESCO.

Secession *see* SEZESSION.

Section d'Or (Fr. "golden section") offshoot of CUBISM; members included Fernand Léger, Marcel Duchamp, Frank Kupka, Jacques Villon. The members shared an interest in a mathematical system of PROPORTION, and the harmonious use of color, and took their name from Luca Pacioli's 1509 treatise on the "divine proportion" of the GOLDEN SECTION. They held an exhibition in 1912 and had a magazine of the same name.

Seicento (It.) 17th century.

self-portrait PORTRAIT of and by the artist.

semiabstraction the name used by Pablo Picasso and his circle for ABSTRACTION.

sepia blackish-brown secretion of ink from cuttlefish and squid, used as a drawing MEDIUM and in WATERCOLOR.

series paintings art form of the 1960s involving the repetition of an image with slight variations. Also known as "serial painting." For example, Andy Warhol's SILK-SCREEN PRINTS.

serpentine sinuous, winding.

Seven and Five society English art association formed in 1920 by seven painters and five sculptors, including Barbara Hepworth and Ben Nicholson; originally FIGURATIVE, but became ABSTRACT.

Sezession (Ger. "Secession") term used for withdrawal of German and Austrian artists from ACADEMIES in the late 19th century, to form their own independent groups. *See also* BERLINER SEZESSION, MUNICH SEZESSION, NEW SEZESSION, VIENNA SEZESSION.

sfumato (It. "shaded") using subtle gradations of TONE and softened lines. Leonardo da Vinci was the first great exponent of this method.

sgraffito (It. "scratched") decorative TECHNIQUE involving the application of an underlayer of colored PLASTER to a wall; a thin layer of white plaster is applied on top, and a design scratched on the surface that is visible in the color of the underlayer.

shading use of darker TONES to indicate shadowed areas.

silhouette 1 MONOCHROME painting, dark on light or light on dark, with a well-defined outline. **2** PROFILE PORTRAIT cut from black paper and mounted on white; popular in the 18th and 19th centuries.

silk-screen printing method of color reproduction in which colored inks are passed over a STENCIL prepared on a silk screen.*

silverpoint method of DRAWING using a silver wire or stylus on paper coated with opaque white, often tinted with color.

sinopia **1** red-brown earth PIGMENT used in DRAWINGS for FRESCO. The name is derived from the place of origin, the town of Sinope on the Black Sea. **2** the name is also generally applied to the drawing on the *ARRICCIO*, prior to painting the fresco, whether or not the drawing is made in this pigment.

size gelatine or animal glue, or other materials such as starch and gums, used to stiffen fabrics, to reduce the porousness of a surface, or as a painting MEDIUM.

sketch 1 rough DRAWING as the preliminary to a more finished COMPOSITION. **2** since the 18th century, a complete but slight or quickly executed drawing, PAINTING, or WATERCOLOR.

slip clay thinned with water, for decorating or coating pottery.

soapstone a soft stone, easily carved and polished, and often used to make small objects; also used as an ingredient in the manufacture of PORCELAIN.

social realism since the 19th century, the term has referred to the portrayal of subjects in a social or political context. In the 20th century it was applied more specifically to art that deliberately recorded or commented on the political or social conditions and events in society, e.g. *The Passion of Sacco and Vanzetti* (1931–32) by Ben Shahn.

socialist realism the official, conservative STYLE of art in Russia after the 1917 revolution.

soft-ground etching ETCHING TECHNIQUE developed in the late 18th century and used by artists such as Thomas Gainsborough. The GROUND coating the etching plate is softer than usual, creating prints with softer lines.

spectrum the range of colors, red orange, yellow, green, blue, indigo, violet; often seen in a rainbow and produced when white light passes through a TRANSPARENT prism.

square up method of transferring or enlarging a preliminary DRAWING by superimposing a network of squares (or grid) on the original work, and transferring the contents of each square to the new composition.

stained glass glass colored with metal oxides; these are joined with lead strips to form designs, mostly for windows in CHURCHES.

stainless steel chrome steel, non-rusting; used in modern sculpture and ARCHITECTURE.

statuary collection of STATUES, or the making of statues.

statue carved or MOLDED figure in stone, clay, BRONZE, etc.

statuette small STATUE.

stencil design cut in a card or PLATE used for brushing color through to the paper or other medium beneath. Also, **stenciling**.

Stijl, De (Dutch, "The Style") art magazine and association founded in 1917 by Theo Van Doesburg and Piet Mondrian. Associated artists, architects, and designers were influential in promoting functional BAUHAUS design during the 1920s. *See also* NEOPLASTICISM.

still life painting of inanimate objects, such as fruit, flowers, dead game (rabbits, deer, fish, pheasants etc.).

stipple patterning TONE built up with small dots and dabs of color.

stoneware hard pottery made from clay plus a fusible stone (usually feldspar), and FIRED at an extremely high temperature so that the stone is vitrified into a glassy substance.

stopping out in ETCHING, the protection of certain areas of a PLATE with VARNISH to prevent acid from attacking those areas during BITING.

stretcher frame, a frame, usually of wood, on which canvas is stretched prior to PAINTING.

striation 1 pattern of narrow stripes. **2** the representation of DRAPERY by parallel lines, often found in BYZANTINE and ROMANESQUE ART.

stuccatore (It.) plasterer, someone who works in STUCCO.

stucco slow-setting LIME and MARBLE PLASTER that can be modeled and carved in order to decorate interiors.

Silk screen with mask

Base on which paper is placed

Guide block

1

Finished print

Squeegee

2

Silk-screen printing
A mask (a negative of the image made from paper, film, or glue, for example) is placed on a silk screen (1). When ink is drawn over the screen with a squeegee (2), it passes through the silk but not through the mask, leaving an image.

stuccoist *see* STUCCATORE.

studiolo (It.) small office or work room.

study detailed preparatory DRAWING for a larger work; more detailed than a SKETCH.

Sturm, Der (Ger. "The Storm") magazine and art GALLERY in Berlin founded by Herwarth Walden; from 1910 to 1932 it promoted FUTURISM and EXPRESSIONISM, particularly the BLAUE REITER group.

style 1 ancient writing implement. **2** manner of artistic expression, particular to an individual school or period.

sublime 18th-century ESTHETIC idea related to a concept of the grandeur and vastness of nature; the idea was used as a subject matter for painting.

support canvas paper, PANEL, wall, etc. on which a painting or DRAWING is executed.

superrealism type of PAINTING and sculpture popular in Britain and the United States from the 1960s that is worked to such a high degree of finish and minute detail that it is hard to tell apart from a photograph.

suprematism Russian ABSTRACT ART movement of 1913 to 1915, led by Kasimir Malevich, that made wide use of GEOMETRIC elements; hence **suprematists**.

surrealism movement in art and literature between the two world wars that tried to fuse actuality with dreams and unconscious experience, often with bizarre and disturbing results. Closely linked with AUTOMATISM and DADA. Leading surrealist artists were Max Ernst and Salvador Dalí. Also, **surreal, surrealist**. *See also* NEO-ROMANTICISM.

sweet style sentimental STYLE of MARBLE sculpture associated with the WORKSHOP of the della Robbia

family in Florence in the mid-15th century.

symbol image of something representing something else. Also, **symbolic, symbolize.**
The following is a list of symbols commonly appearing in Western art. Such symbols would have been widely understood at the time they were used.
candle symbol of the light of Christian faith; the shortness of human life.
clock the passing of time.
dog traditionally a symbol of fidelity.
dove Christian symbol of the Holy Spirit; also symbol of peace and love.
fish symbol of Christianity.
flag a white flag with a red cross symbolizes the victory of Christianity over death (the Resurrection).
fruit often has symbolic meaning, e.g. the apple alludes to the fall of man and his future redemption through Christ; cherries represent Heaven; grapes the blood of Christ; the pomegranate can symbolize the Resurrection, the unity of the CHURCH or monarch, and also chastity.
ivy symbolizes immortality.
lily symbol of purity.
lute an attribute of Music personified.
palm a symbol of military victory; also a symbol of martyrdom.
skull symbol of death.

symbolism *see* SYMBOLIST MOVEMENT.

symbolist movement (also known generally as symbolism) art movement that appeared c1885 in France, originating with poetry. A reaction against both REALISM and IMPRESSIONISM, it aimed at the fusion of the real and spiritual worlds, and the visual expression of the mystical.

synchromism (literally, "colors together") an American movement

of 1913 promoted by Morgan Russell and Stanton Macdonald-Wright; influenced by ORPHISM using ABSTRACT form and color.

synthesism a branch of POST-IMPRESSIONIST painting associated with Gauguin, c1888, chiefly employing flat areas of color, strong contour lines, and simple forms; also called cloisonnism.

synthesists *see* SYNTHESISM.

synthetic cubism the second phase of CUBISM, after 1912, using COLLAGE.

T

tabernacle (arch.) NICHE or receptacle in a CHURCH containing the Holy Sacrament, usually above the altar.

tachisme (from Fr. *tache*, "spot," "mark") term coined in 1952 by the French critic Michel Tapie to describe the TECHNIQUE of painting in an apparently haphazard manner using irregular dabs.

tapestry wall hanging of silk or wool with a nonrepeating pattern or narrative design woven in by hand during manufacture. *See also* CARTOON.

technique method of execution.

tempera (egg tempera) TECHNIQUE of painting in which egg, or more commonly egg yolk, is blended into PIGMENT and used as a MEDIUM; before the late 15th century it was the most common medium used on PANEL PAINTINGS.

Ten, The group of painters from New York and Boston who were influenced by IMPRESSIONISM and who exhibited together from 1898 to c1918. They included Childe Hassam.

tenebrism STYLE of 17th-century painting that makes much use of strong CHIAROSCURO. The term comes from the Italian word *tenebroso*, meaning "dark;"

Bar *Reticulated*

Tracery
Tracery, the use of decorative bars in window openings, developed in GOTHIC *architecture. Bar tracery dates from c1245, and reticulated (networked) from the early 14th century. By the late 14th century the designs were highly complex.*

"shady;" the style is associated with the work of Caravaggio and his followers.

terracotta (It. "baked earth") hard, fired, but unglazed brown-red clay used for pottery, sculpture, and building.

tessellation pattern of MOSAIC or pavement floor, composed of blocks of stone, MARBLE, etc.

The Antique *see* ANTIQUE.

The Eight *see* Eight, The.

The Ten *see* Ten, The.

tint hue, or shade of a color.

tonality quality of color, light, and shade in painting.

tondo (It. "round") circular picture or RELIEF carving.

tone 1 atmosphere, character. **2** intensity of color or hue. **3** degree of lightness or darkness.

tooling term used in metal carving to refer to DECORATIVE marks made on the surface by a variety of tools; or, in coin or MEDAL production, to refer to the crafting of a DIE.

trace (verb) to draw or copy, especially from a DRAWING, on a

superimposed TRANSPARENT sheet.

tracery (arch.) ornamental stonework in window openings, especially in GOTHIC ARCHITECTURE.*

translucent able to transmit light without being completely TRANSPARENT. *See also* OPAQUE.

transparent allowing light to pass through. *See also* OPAQUE.

Trecento (It.) the 14th century.

Trinità (It.) representation of the Holy Trinity: the Father, the Son, and the Holy Ghost.

triptych picture or carving in three parts; a form of POLYPTYCH common for ALTARPIECES.

trompe l'oeil (Fr. "deceives the eye") type of illusionistic painting characterized by its very precise NATURALISM.

trumeau PILLAR dividing a portal.

turquoise blue-green semi-precious stone, often used for INLAY.

typography the art of creating type. Also, **typographer.**

U

ukiyo-e (Jap. "pictures of the floating world") Japanese paintings and WOODBLOCK prints of the 17th to 19th centuries. Their subjects were actors, courtesans, and everyday domestic scenes, and they were a great inspiration to French avant-garde artists.

underpainting the first layer of a painting that establishes forms and TONE, and is then modified by GLAZES and SCUMBLES.

Unit One group of AVANT-GARDE English artists formed in 1933, including Henry Moore, Barbara Hepworth, John Nash, and Ben Nicholson. The group broke up in 1935, but had considerable impact on British art in the 1930s.

Woodcuts
The design is first painted or pasted onto a wooden block, then the surrounding wood is cut away. Ink is rolled onto the block, which is then pressed against a surface to form a print. Color woodcuts are made by cutting a separate woodblock for each color. The blocks need to be exactly the same size to ensure that the printed colors are properly "registered" (in the correct place in relation to each other). Historically, fine-grained hardwoods were the most popular woods used for the block, as they enabled artists to produce more detailed work than softwoods.

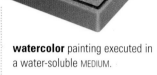

Printed woodcut

Woodblock with image cut in RELIEF

V

vanishing point point at which the receding parallel lines in a painting appear to meet. *See* LINEAR PERSPECTIVE, FORESHORTENING, ORTHOGONAL.

vanitas STILL-LIFE painting, popular from the 17th century, which contains objects and SYMBOLS as reminders of the impermanence of life, and of mortality.

varnish natural or synthetic resinous solution applied to furniture and paintings to color and provide a glossy, protective surface. Also used for STOPPING OUT in ETCHING.

vedute (It. "views") DRAWING or painting of a place, most commonly a townscape, which is accurate enough to be recognizable, as exemplified in views by Giovanni Canaletto, Francesco Guardi, or Giovanni Battista Piranesi in the 18th century.

vellum fine calfskin, used in writing and painting, and for bookbinding.

Venice Biennale famous art exhibition held every two years in Venice. It began in 1895, and still exhibits the work of major international modern artists. *See also* BIENNALE.

Vienna Sezession radical movement led by Gustav Klimt in an attempt to improve Austrian art, c1897. It had strong links with JUGENDSTIL (ART NOUVEAU). *See also* SEZESSION.

Vingt, Les (or **Les XX**) group of radical Belgian artists, including James Ensor and Jan Troop, who exhibited regularly together in Brussels between 1884 and 1893. They also showed work by other progressive artists such as Vincent Van Gogh, Paul Cézanne, and Georges Seurat. They were influential in spreading the ideas of POSTIMPRESSIONISM, SYMBOLISM, and Belgian ART NOUVEAU.

Virtues PERSONIFICATION of the seven Virtues (Faith, Hope, Charity, Prudence, Justice, Temperance, Fortitude) often depicted as gods and goddesses.

virtuosity special skill of execution.

vitreous glaze in pottery, a GLAZE that becomes glass-like (vitrifies) on FIRING.

Vitruvian derived from the writings of Vitruvius (1st century BC), author of *De Re Architectura*, an important and influential treatise on ARCHITECTURE and the only one to survive from ANTIQUITY.

vorticism short-lived English AVANT-GARDE movement, the most prominent member of which was Wyndham Lewis. Its name derives from a magazine published by the group in 1914: *Blast! A Review of the Great English Vortex.*

W

wash (noun) diluted WATERCOLOR; (verb) to apply a thin coat of diluted watercolor over a large area to establish a general TONE.

watercolor painting executed in a water-soluble MEDIUM.

wax moldable substance produced by bees, or of vegetable origin, used for MODELING.

welding fusing together pieces of the same material, such as METAL or PLASTIC, with heat.

woodcut a design cut to stand out in RELIEF from a woodblock; the PRINT made from a woodblock. *See also* NEOPRIMITIVISM.*

wood engraving a design engraved with a burin (engraver's tool) on hardwood. The printing method is as for the WOODCUT.

workshop place in which art objects or paintings are executed. "Workshop" work is usually not by the MASTER but by his assistants.

Y

Yellow Book quarterly magazine published from 1894, of which Aubrey Beardsley (1872–1898) was art editor.

Z

zigzag pattern formed of lines that make abrupt right and left turns.

zoomorphism 1 in art, the use of animal forms or symbols. **2** the representation of gods in animal form.

FURTHER READING

Abstract art

Arnason, H. H. *History of Modern Art: Painting, Sculpture, Architecture.* Rev. ed. New York: Abrams, 1977.

Lucie-Smith, Edward. *Movements in Art Since 1945.* London: Thames & Hudson, 1984.

Moszynska, Anna. *Abstract Art.* London: Thames & Hudson, 1990.

Rosenthal, Mark. *Abstraction in the Twentieth Century: Total Risk, Freedom, Discipline.* New York: Abrams, 1996.

Stangos, Nikos, ed. *Concepts of Modern Art.* London: Thames & Hudson, 1981.

Whitford, Frank. *Understanding Abstract Art.* London: Barrie & Jenkins, 1987.

Abstract expressionism

Solomon R. Guggenheim Museum. *American Abstract Expressionists and Imagists.* New York: Solomon R. Guggenheim Museum, 1961.

Hess, Thomas. *Abstract Painting: Background and American Phase.* New York: Viking, 1951.

Polcari, Stephen. *Abstract Expressionism and the Modern Experience.* Cambridge: Cambridge University Press, 1991.

Rose, Barbara. *American Painting: The 20th Century.* New York: Rizzoli, 1986.

Sandler, Irving. *Abstract Expressionism: The Triumph of the American Painting.* New York: Praeger, 1970.

Shapiro, David and Cecile. *Abstract Expressionism.* Cambridge: Cambridge University Press, 1990.

Art nouveau

Duncan, Alastair. *Art Nouveau.* London: Thames & Hudson, 1994.

Haslam, Malcolm. *In the Nouveau Style.* London: Thames & Hudson, 1989.

Johnson, Diane. *American Art Nouveau.* New York: Abrams, 1979.

Ashcan school

Glackens, Ira. *William Glackens and The Eight: The Artists Who Freed American Art.* New York: Horizon, 1983.

Hughes, Robert. *American Visions: The Epic History of Art in America.* New York: Alfred A. Knopf, 1997.

Zurier, Rebecca, et. al. *Metropolitan Lives: The Ashcan Artists and Their New York.* Washington, D.C.: National Museum of American Art, 1995.

Avant-garde

Crane, Diane. *The Transformation of the Avant-Garde: The New York Art World 1940–1985.* Chicago: University of Chicago Press, 1987.

Edwards, Steve. *Art and Its Histories: A Reader.* New Haven: Yale University Press, 1999.

Fernie, Eric. *Art History and Its Methods: A Critical Anthology.* London: Phaidon, 1995.

Barbizon school

Adams, Steven. *The Barbizon School and the Origins of Impressionism.* London: Phaidon, 1994.

Bouret, Jean. *The Barbizon School and 19th-Century French Landscape Painting.* London: Thames & Hudson, 1973.

Baroque

Calloway, Stephen. *Baroque Baroque: The Culture of Excess.* London: Phaidon, 1994.

Hennessey, J. Pope. *Italian High Renaissance and Baroque Sculpture.* 4th ed. London: Phaidon, 1996.

Minor, Vernon Hyde. *Baroque & Rococo: Art & Culture.* New York: Abrams, 1999.

Wittkower, Rudolf. *Art and Architecture in Italy 1600–1750: The High Baroque 1625–1675.* New Haven: Yale University Press, 2000.

———. *Bernini: The Sculptor of the Roman Baroque.* New York: Phaidon, 1997.

Bauhaus

Droste, Magdalena. *Bauhaus 1919–1933.* New York: Taschen, 1998.

Franciscono, Marcel. *Walter Gropius and the Creation of the Bauhaus at Weimar.* Urbana: University of Illinois Press, 1971.

Hochman, Elaine S. *Bauhaus: Crucible of Modernism.* New York: Fromm, 1997.

Whitford, Frank. *Bauhaus.* London: Thames & Hudson, 1984.

Die Brücke and Der Blaue Reiter

Herbert, Barry. *German Expressionism: Die Brücke and Der Blaue Reiter.* London: Jupiter, 1983.

Vezin, Annette, et. al. *Kandinsky and Der Blaue Reiter.* Paris: Terrail, 1996.

Byzantine

Cormack, Robin. *Byzantine Art.* New York: Oxford University Press, 2000.

Lowden, John. *Early Christian and Byzantine Art.* New York: Phaidon, 1997.

Mathews, Thomas F. *Byzantium: From Antiquity to the Renaissance.* New York: Abrams, 1998.

Classicism

Blunt, Anthony, and Richard Beresford. *Art and Architecture in France, 1500–1700.* 5th rev. ed. New Haven: Yale University Press, 1999.

Daniel, Sergei, and Natalia Serebriannaya. *Claude Lorrain:*

Painter of Light. New York: Parkstone, 1996.

Hargrove, June. ed. *The French Academy: Classicism and Its Antagonists.* Newark: University of Delaware Press, 1990.

Langdon, Helen. *Claude Lorrain.* London: Phaidon, 1989.

Conceptual art
Alberro, Alexander, and Blake Stimson, eds. *Conceptual Art: A Critical Anthology.* Cambridge, Mass.: MIT Press, 1999.

Godfrey, Tony. *Conceptual Art.* New York: Phaidon, 1998.

Reiss, Julie H. *From Margin to Center: The Spaces of Installation Art.* Cambridge, Mass.: MIT Press, 2000.

Constructivism
Gray, Camilla. *The Great Experiment: Russian Art 1863–1922.* New York: Abrams, 1962.

Henry Art Gallery. *Art Into Life: Russian Constructivism, 1914–1932.* New York: Rizzoli, 1990.

Lodder, Christina. *Russian Constructivism.* New Haven: Yale University Press, 1983.

Rowell, Margit. *The Planar Dimension: Europe, 1912–1932.* New York: Solomon R. Guggenheim Foundation, 1979.

Cubism
Barr, Alfred H. *Cubism and Abstract Art.* Cambridge: Belknap, 1986.

Cooper, Douglas. *The Cubist Epoch.* London: Phaidon, 1995.

Cottingham, David. *Cubism.* New York: Cambridge University Press, 1998.

Golding, John. *Cubism: A History and Analysis, 1907–1914.* 3rd ed. Cambridge: Harvard University Press, 1988.

Poggi, Christine. *In Defiance of Painting: Cubism, Futurism, and the Invention of Collage.* New Haven: Yale University Press, 1993.

Rubin, William. *Picasso and Braque: Pioneering Cubism.* New York: Museum of Modern Art, 1989.

Dada
Camfield, William A., et. al. *Max Ernst: Dada and the Dawn of Surrealism.* New York: Prestel, 1993.

Gale, Matthew. *Dada and Surrealism.* London: Phaidon, 1997.

Motherwell, Robert, ed. *The Dada Painters and Poets: An Anthology.* Cambridge: Belknap, 1981.

Naumann, Francis M. et. al. *Making Mischief: Dada Invades New York.* New York: Whitney Museum of American Art, 1997.

Richter, Hans. *Dada: Art and Anti-Art.* Reprint, London: Thames & Hudson, 1997.

Expressionism
Barron, Stephanie, et. al. *German Expressionism: Art and Society.* New York: Rizzoli, 1997.

Elger, Dietmar. *Expressionism: A Revolution in German Art.* New York: Taschen, 1998.

Lloyd, Jill. *German Expressionism: Primitivism and Modernity.* New Haven: Yale University Press, 1991.

Raabe, Paul, ed. *The Era of German Expressionism.* New York: Overlook, 1986.

Selz, Peter Howard. *German Expressionist Painting.* Berkeley: University of California Press, 1983.

Fauvism
Freeman, Judi. *The Fauve Landscape.* New York: Abbeville, 1990.

Herbert, James D. *Fauve Painting: The Making of Cultural Politics.* New Haven: Yale University Press, 1992.

Leymarie, Jean. *Fauves and Fauvism.* New York: Rizzoli, 1987.

Whitfield, Sarah. *Fauvism.* London: Thames & Hudson, 1996.

Folk art
Bihalji-Merin, Oto. *Modern Primitives.* London: Thames & Hudson, 1975.

Ferris, William, ed. *Afro-American Folk Arts and Crafts.* Boston: G. K. Hall, 1983.

Ickis, Marguerite. *Folk Arts and Crafts.* New York: Association Press, 1958.

Janis, Sidney. *They Taught Themselves: American Primitive Painters of the 20th Century.* New York: Dial Press, 1942.

Lipmann, Jean, and Alice Winchester. *The Flowering of American Folk Art.* London: Thames & Hudson, 1975.

Futurism
Apollonio, Umbro, ed. *Futurist Manifestos.* London: Thames & Hudson, 1973.

Hulten, Karl Gunnar Pontus. *Futurism and Futurisms.* New York: Abbeville, 1986.

Kozloff, Max. *Cubism/Futurism.* New York: Charterhouse, 1973.

Poggi, Christine. *In Defiance of Painting: Cubism, Futurism, and the Invention of Collage.* New Haven: Yale University Press, 1993.

Tisdale, Caroline, and Angelo Bozollo. *Futurism.* London: Thames & Hudson, 1985.

Gothic
Brooks, Chris. *The Gothic Revival.* New York: Phaidon, 1999.

Camille, Michael. *Gothic Art: Glorious Visions.* New York: Abrams, 1996.

Toman, Rolf, ed. *Gothic: Architecture, Sculpture, Painting.* New York: Konemann, 1999.

White, John. *Art and Architecture in Italy 1250–1400.* 3rd ed. New Haven: Yale University Press, 1993.

Williamson, Paul. *Gothic Sculpture 1140–1300.* New Haven: Yale University Press, 1995.

Harlem Renaissance

Bontemps, Arna, ed. *The Harlem Renaissance Remembered.* New York: Dodd, Mead, 1972.

Driskell, David C., ed. *Harlem Renaissance: Art of Black America.* New York: Abradale, 1994.

Kellner, Bruce. *The Harlem Renaissance.* Westport, Conn.: Greenwood, 1995.

Marks, Carole, and Diana Edkins. *The Power of Pride: Stylemakers and Rulebreakers of the Harlem Renaissance.* New York: Crown, 1999.

Powell, Richard J., ed. *Rhapsodies in Black: Art of the Harlem Renaissance.* Berkeley: University of California Press, 1997.

Hudson River school

Driscoll, John. *All That Is Glorious Around Us: Paintings from the Hudson River School.* Ithaca: Cornell University Press, 1997.

Howat, John K., introduction by. *American Paradise: The World of the Hudson River School.* New York: Metropolitan Museum of Art, 1987.

Lassiter, Barbara Babcock. *American Wilderness: The Hudson River School of Painting.* Garden City, N.Y.: Doubleday, 1977.

Impressionism

Denvir, Bernard. *The Thames and Hudson Encyclopedia of Impressionism.* London: Thames & Hudson, 1990.

Feist, Peter H. *French Impressionism: 1860–1920.* New York: Taschen, 1996.

Herbert, Robert. *Impressionism: Art, Leisure, and Parisian Society.* New Haven: Yale University Press, 1998.

Neff, Emily Ballew, and George T. Shackelford. *American Painters in the Age of Impressionism.* Boston: Museum of Fine Arts, 1996.

Rathbone, Eliza E., et. al. *Impressionists on the Seine: A Celebration of Renoir's Luncheon of the Boating Party.* Washington, D.C.: Counterpoint, 1996.

Rewald, John. *Studies in Impressionism.* New York: Abrams, 1986.

Rubin, James Henry. *Impressionism.* New York: Phaidon, 1999.

Weinberg, H. Barbara. *American Impressionism and Realism: The Painting of Modern Life, 1885–1915.* New York: Metropolitan Museum of Art, 1994.

Mannerism

Freedberg, Sydney. *Painting in Italy, 1500–1600.* 4th ed. New Haven: Yale University Press, 1993.

Friedländer, Walter F. *Mannerism and Anti-Mannerism in Italian Painting.* New York: Columbia University Press, 1990.

Murray, Linda Lefevre. *The High Renaissance and Mannerism: Italy, the North, and Spain, 1500–1600.* London: Thames & Hudson, 1985.

Shearman, John. *Mannerism.* Paperback reissue. New York: Viking, 1990.

Minimalism

Baker, Kenneth. *Minimalism: Art of Circumstance.* New York: Abbeville, 1997.

Krauss, Rosalind E. *Passages in Modern Sculpture.* Cambridge, Mass.: MIT Press, 1981.

Meyer, James, ed. *Minimalism.* New York: Phaidon, 2000.

Strickland, Edward. *Minimalism: Origins.* Bloomington: Indiana University Press, 1993.

Neoclassicism

Boime, Albert. *Art in an Age of Revolution, 1750–1800.* Chicago: University of Chicago Press, 1987.

Honour, Hugh. *Neoclassicism* London: Penguin, 1968.

Irwin, David G. *Neoclassicism.* New York: Phaidon, 1997.

Op art

Barrett, Cyril. *Op Art.* New York: Viking, 1970.

Lucie-Smith, Edward. *Movements in Art Since 1945.* London: Thames & Hudson, 1984.

Parola, Rene. *Optical Art: Theory and Practice.* New York: Van Nostrand Reinhold, 1969.

Pop art

Alloway, Lawrence. *Modern Dreams: The Rise and Fall and Rise of Pop.* Cambridge, Mass.: MIT Press, 1988.

De Salvo, Donna, et. al. *Hand-Painted Pop: American Art in Transition, 1955–62.* New York: Rizzoli, 1992.

Lippard, Lucy R. *Pop Art.* London: Thames & Hudson, 1985.

Madoff, Steven Henry, ed. *Pop Art: A Critical History.* Berkeley: University of California Press, 1997.

Postimpressionism

Denvir, Bernard. *Post-Impressionism.* London: Thames & Hudson, 1992.

Rewald, John. *Postimpressionism from Van Gogh to Gauguin.* New York: Museum of Modern Art, 1962.

Thompson, Belinda. *The Post-Impressionists.* London: Phaidon, 1995.

Postmodernism/kitsch

Docker, John. *Postmodernism and Popular Culture: A Cultural History.* New York: Cambridge University Press, 1995.

Jencks, Charles. *What Is Post-modernism?* New York: St. Martin's Press, 1989.

Taylor, Brandon. *The Art of Today.* London: Everyman Art Library, 1995.

Pre-Raphaelite Brotherhood

Barnes, Rachel. *The Pre-Raphaelites and Their World.* London: Tate Gallery Publications, 1998.

Hewison, Robert, et. al. *Ruskin, Turner, and the Pre-Raphaelites.* London: Tate Gallery Publications, 2000.

Parris, Leslie, ed. *The Pre-Raphaelites.* Seattle: University of Washington Press, 1995.

Primitivism

Fineberg, Jonathan David, et. al, eds. *Discovering Child Art: Essays on Childhood, Primitivism, and Modernism.* Princeton: Princeton University Press, 1998.

Rhodes, Colin. *Primitivism and Modern Art.* London: Thames & Hudson, 1994.

Rubin, William, ed. *Primitivism in 20th-Century Art: Affinity of the Tribal and the Modern.* New York: Museum of Modern Art, 1984.

Realism

Fried, Michael. *Courbet's Realism.* Chicago: University of Chicago Press, 1992.

Nochlin, Linda. *Realism.* New York: Viking, 1993.

Novotny, Fritz. *Painting and Sculpture in Europe 1780–1880.* Pelican History of Art. London: Penguin Books, 1960.

Renaissance

Gallwitz, Karl Ludwig. *The Handbook of Italian Renaissance Painters.* New York: Prestel, 1999.

Goldscheider, Ludwig. *Michelangelo: Paintings, Sculpture, Architecture.* London: Phaidon, 1996.

McHam, Sarah Blake. *Looking at Italian Renaissance Sculpture.* New York: Cambridge University Press, 1998.

Paoletti, John T., et. al. *Art in Renaissance Italy.* New York: Abrams, 1997.

Snyder, James. *Northern Renaissance Art.* New York: Abrams, 1985.

Welch, Evelyn S. *Art and Society in Italy 1350–1500.* New York: Oxford University Press, 1997.

Rococo

Levey, Michael. *Rococo to Revolution: Major Trends in Eighteenth-Century Painting.* London: Thames & Hudson, 1985.

Minor, Vernon Hyde. *Baroque & Rococo: Art & Culture.* New York: Abrams, 1999.

Park, William. *The Idea of Rococo.* Wilmington: University of Delaware Press, 1993.

Pignatti, Terisio. *The Age of Rococo.* London: Cassell, 1988.

Romanesque

Petzold, Andreas. *Romanesque Art.* New York: Abrams, 1995.

Toman, Rolf, ed. *Romanesque: Architecture, Sculpture, Painting.* New York: Konemann, 1998.

Romanticism

Vaughan, William. *German Romantic Painting.* New Haven: Yale University Press, 1994.

Vaughan, William. *Romanticism and Art.* London: Thames & Hudson, 1994.

Wolf, Norbert, and Ingo F. Walther, eds. *Painting of the Romantic Era.* New York: Taschen, 1999.

De Stijl

Jaffé, Hans L. C. *De Stijl 1917–1931: The Dutch Contribution to Modern Art.* Cambridge: Belknap, 1986.

Overy, Paul. *De Stijl.* London: Thames & Hudson, 1991.

Surrealism

Barr, Alfred H., ed. *Fantastic Art, Dada, Surrealism.* New York: Museum of Modern Art, 1936.

Bradley, Fiona. *Surrealism.* New York: Cambridge University Press, 1998.

Breton, André. *Manifestoes of Surrealism.* Ann Arbor: University of Michigan Press, 1972.

Gale, Matthew. *Dada and Surrealism.* London: Phaidon, 1997.

Nadeau, Maurice. *The History of Surrealism.* Cambridge: Belknap, 1989.

Rubin, William S. *Dada, Surrealism, and Their Heritage.* New York: Museum of Modern Art, 1968.

Symbolism

Dorra, Henri, ed. *Symbolist Art Theories: A Critical Anthology.* Berkeley: University of California Press, 1994.

Mathieu, Pierre-Louis. *The Symbolist Generation, 1870–1910.* New York: Rizzoli, 1991.

Théberge, Pierre. *Lost Paradise: Symbolist Europe.* Montreal: Montreal Museum of Fine Arts, 1995.

Utrecht school

Brown, Christopher. *Utrecht Painters of the Dutch Golden Age.* London: National Gallery, 1997.

Slive, Seymour. *Dutch Painting 1600–1800.* New Haven: Yale University Press, 1995.

ENTRIES BY AUTHOR

Christopher Ackroyd

Andrea del Sarto
Bartolommeo, Fra
Canova, Antonio
Cézanne, Paul
Constable, John
Ensor, James
Fragonard, Jean-Honoré
Gericault, Théodore
Leonardo da Vinci
Michelangelo Buonarroti
Pontormo
Raphael
Tiepolo, Giambattista
Tintoretto

Michael Bird

Blake, William
Chagall, Marc
Degas, Edgar
Freud, Lucian
Goya, Francisco
Hockney, David
Johns, Jasper
Lorraine, Claude
Moore, Henry
Rouault, Georges
Seurat, Georges
Turner, J. M. W.
Van Gogh, Vincent

Maria Costantino

Audubon, J. J.
Bearden, Romare
Beccafumi, Domenico
Benton, Thomas Hart
Bourgeois, Louise
Calder, Alexander
Catlin, George
Cole, Thomas

Cossa, Francesco del
Dove, Arthur
Elsheimer, Adam
Frankenthaler, Helen
Gorky, Arshile
Giovanni di Paolo
Hassam, Childe
Henri, Robert
Hesse, Eva
Hicks, Edward
Inness, George
Kauffmann, Angelica
Krasner, Lee
Marin, John
Nolan, Sidney
O'Keeffe, Georgia
Orozco, José
Pippin, Horace
Rockwell, Norman
Rublev, Andrei
Ryder, Albert Pinkham
Shahn, Ben
Sluter, Claus
Utrillo, Maurice
West, Benjamin
Wood, Grant
Wyeth, Andrew
Abstract art
Ashcan school
Avant-garde
Conceptual art
Constructivism
Folk art
Harlem Renaissance
Hudson River school
Neoclassicism
Op art
Pop art
Postmodernism/kitsch
Primitivism
Rococo
Romanesque
Utrecht school

Michael Ellis

Bacon, Francis
Bosch, Hieronymus
Campin, Robert
Crivelli, Carlo
Dine, Jim
Duchamp, Marcel
Dürer, Albrecht
Holbein, Hans
Hopper, Edward
Kahlo, Frida
Lichtenstein, Roy
Limbourg Brothers
Malevich, Kasimir
Memling, Hans
Miró, Joan
Mondrian, Piet
Motherwell, Robert
Newman, Barnett
Oldenberg, Claes
Pollock, Jackson
Rauschenberg, Robert
Rothko, Mark
Segal, George
Van Der Weyden, Rogier
Van Eyck, Jan
Vermeer, Jan
Warhol, Andy

Flavia Heseltine

Barbizon
Baroque
Byzantine
Classicism
Gothic
Postimpressionism
Realism
Renaissance

Michael Howard

Bonnard, Pierre
Chirico, Giorgio de
Dalí, Salvador
Daumier, Honoré
David, Jacques-Louis
Delacroix, Eugène
Lowry, L. S.
Matisse, Henri
Moreau, Gustave

Dr Debbie Lewer

Ernst, Max
Gainsborough, Thomas
Grosz, George
Kandinsky, Wassily
Kirchner, Ernst Ludwig
Klee, Paul
Kokoschka, Oskar
Macke, August
Modersohn-Becker, Paula
Munch, Edvard
Nolde, Emil
Rego, Paula
Rodin, Auguste
Soutine, Chaïm
Bauhaus
Dada
Futurism
Minimalism
Surrealism
Symbolism

Rebecca Lyons

Angelico, Fra
Bellini, Gentile
Bellini, Giovanni
Bernini, Gianlorenzo
Boucher, François
Bronzino, Agnolo

Caravaggio, Michelangelo
 Merisi da
Carracci, Annibale
Chardin, Jean-Baptiste-
 Siméon
Copley, John
Correggio, Antonio
Gentile da Fabriano
Gentileschi, Artemesia
Giorgione
Ingres, Jean Auguste
 Dominique
La Tour, Georges de
Lippi, Fra Filippo
Lotto, Lorenzo
Mantegna, Andrea
Pisano, Andrea
Poussin, Nicolas
Rousseau, Henri
Velázquez, Diego
Watteau, Antoine
Zurburán, Francisco de

Dr Claire O'Mahony

Millet, Jean-François
Monet, Claude
Morisot, Berthe
Morris, William
Pissarro, Camille
Redon, Odilon
Renoir, Pierre Auguste
Rossetti, Dante Gabriel
Sargent, John Singer
Sisley, Alfred
Vuillard, Edouard
Whistler, James Abbot
 McNeill

Dr Mike O'Mahony

Balla, Giacomo
Beckmann, Max
Bellows, George
Brancusi, Constantin
Braque, Georges
Davis, Stuart
Delaunay, Robert
Demuth, Charles
Derain, André
Dufy, Raoul
Friedrich, Caspar David
Giacometti, Alberto
Goncharova, Natalia
Greco, El
Gris, Juan
Leger, Fernand
Magritte, René
Manet, Edouard
Marc, Franz
Modigliani, Amedeo
Picasso, Pablo
Rivera, Diego
Schiele, Egon
Spencer, Stanley
Stubbs, George

Chris Murray

Gauguin, Paul
Piero della Francesca
Abstract expressionism
Mannerism

Alice Peebles

Art Nouveau
Der Blaue Reiter
Die Brücke
Cubism
Expressionism
Fauvism
De Stijl

Anthea Peppin

Antonello da Messina
Canaletto, Giovanni
Carpaccio, Vittore
Cimabue
Duccio di Buoninsegna
Fouquet, Jean
Geertgen tot Sint Jans
Giotto di Bondone
Giovanni di Paolo
Hals, Frans
Hilliard, Nicholas
Martini, Simone
Masaccio
Perugino, Pietro
Rembrandt
Reynolds, Joshua
Uccello, Paolo

Ailsa Turner

Botticelli, Sandro
Ghiberti, Lorenzo
Ghirlandaio, Domenico
Gozzoli, Benozzo
Sassetta, Stefano

Giles Waterfield

Arcimboldo, Giuseppe
Murillo, Bartolomé
Rubens, Peter Paul
Van Dyck, Anthony
Veronese, Paolo

Iain Zaczek

Bruegel, Pieter
Burne-Jones, Edward
Cassatt, Mary
Corot, Camille
Courbet, Gustave
Eakins, Thomas
Grünewald, Mathis
Homer, Winslow
Klimt, Gustav
Lawrence, Thomas
Robbia, Luca della
Titian
Impressionism
Pre-Raphaelite Brotherhood
Romanticism

INDEX

This index gives the volume number followed by page reference; page numbers in *italic* refer to illustrations. **Bold** type denotes main entries.

A

G

H

Picture credits